OTTO · PING

OTTO · PING

PHOTOGRAPHER OF BROWN COUNTY, INDIANA

1900 · 1940

W. DOUGLAS HARTLEY

ESSAYS BY ANNE E. PETERSON AND STEPHEN J. FLETCHER

INDIANA HISTORICAL SOCIETY

INDIANAPOLIS 1994

Library of Congress Cataloging-in-Publication Data

Hartley, W. Douglas.
 Otto Ping : photographer of Brown County, Indiana, 1900-1940 / W.
Douglas Hartley ; essays by Anne E. Peterson and Stephen J.
Fletcher
 p. cm.
 Includes bibliographical references.
 ISBN 0-87195-105-3 : $19.95
 1. Photography, Artistic. 2. Brown County (Ind.)–Social life and
customs–Pictorial works. 3. Photography–Indiana–Brown County–
History–20th century. 4. Ping, Otto, 1883-1975. I. Ping, Otto,
1883-1975. II. Peterson, Anne E. III. Fletcher, Stephen J.
IV. Indiana Historical Society. V. Title.
TR653.H37 1994
770'.92–dc20
 94-22242
 CIP

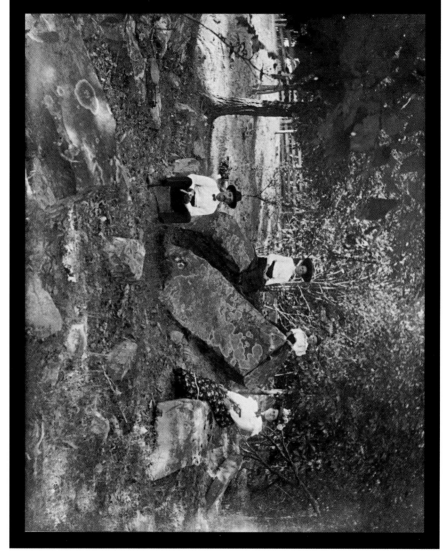

Pike's Peak. ca. 1900.

Contents

Contents

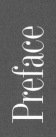

Preface

There are many reasons why the images that are contained in this book should not have survived. There are, by the same token, reasons why Otto Ping could not have become a photographer of importance.

Yet, he made hundreds of glass-plate and film negatives that chronicle a period of Indiana history with great clarity. The resulting images depict life in the Brown County hill region during a forty-year period when life in America was changing. The move from horse to automobile and from kerosene to electricity that transformed the country came slowly to Brown County, Indiana, where the aura of the last century still hangs in the air.

The author first met Otto Ping in the early 1960s while doing field research on Henry Cross, a local farmer and tombstone carver who was killed in a farming accident during the Civil War. After several visits, Ping told the author that he had once been a photographer and that he would be glad to show him some of his work. When he first mentioned to the author that he used to take pictures, there was a touch of pride in his voice. He said it as though he had forgotten, until that moment, all those years when he traveled through the hills with his camera, making unforgettable images of an important part of our past.

From this conversation, the author's interest in the Otto Ping photographic legacy was born. The author later realized that the antebellum tombstone carver lived on the same site that was to become the Ping house.

As he grew older, Ping was haunted by the possibility that his total life's work as a photographer might be lost after his death. He had not, during his lifetime, received any significant recognition. A few of his photographs had been published in Columbus's *Evening Republican* (now known as the *Republic*) and the *Brown County Democrat*. He never considered himself an artist and would not have known how to get any recognition. He was inherently a modest man who worked hard all of his life and kept his sense of humor in spite of everything. His wife Clara worked beside him and helped with virtually all of the chores, from slopping the pigs to cutting firewood.

Ping's work has been preserved in the Indiana Historical Society Library, and this book is a belated tribute to one of Indiana's historic regional photographers.

—W. Douglas Hartley

Otto Ping, 1883–1975

Otto Ping and Clara Ewers.

Otto Ping was born on 3 April 1883 in Brown County to Emaline Henderson and Logan Ping. He had two half brothers and two half sisters and seven brothers and sisters. All were born in a log cabin in Brown County. In time, his parents built a larger house in Christiansburg, a hamlet located southeast of Nashville and south of Pike's Peak, Indiana. Otto stayed at home as a young man trying to find a vocation.

At age seventeen, Otto Ping bought a Sears and Roebuck camera by mail and proceeded to learn how to use it. He selected a No. 2 folding box camera known as the Monarch. For $12.95 he received the box with lens, shutter, one double plate holder (5 x 7 size), and a "complete book of instructions on photography, by which anyone can easily take, make and develop pictures."

In Brown County in 1900 it was unusual for a teenage boy to find the money and motivation to make such a purchase. Ping, however, apparently saw the possibilities for a career as a photographer. He had a ready-made clientele in the residents of Van Buren Township since few owned cameras. Not having a studio, he became something of an itinerant photographer and traveled to the houses or cabins of people who were ready to pose for and purchase pictures. For taking, developing, printing, and delivering a photograph he received about a dollar. Otto Ping made many of his most memorable images during the first decade of this century when he was still living at home and going out on excursions to make pictures. During the course of the next forty years Ping bought other cameras, and he continued to make mainly individual and family portraits until about 1940.

Among his early family photographs are "Ewers Family at the Saw Mill" and "Ewers Family Working the Timbers Near Shoals." He met this family while on one of his photographic excursions in search of work. He followed the Ewers family around because he had fallen in love with the Ewers's daughter Clara. Early photographs show that she was, indeed, a slim, attractive young woman. At the time of Otto and Clara's courtship, and for an unknown number of years before, the Ewers family had no house, but lived in a tent. They were loggers and moved from one woods to another, taking tent, team, tools, and personal belongings with them.

Eventually, persistence paid off, and Clara Ewers left her logging family to marry Otto Ping, the handsome young man with a camera. They were married in Brown County on 19 June 1910 and moved in with his parents in Christiansburg. Their first child, Bernice Irene, was born a year later. The three of them stayed with the elder Pings for a period of about a year. Apparently the "big house" in Christiansburg burned to the ground in 1912. With the house, all of Otto Ping's cameras were destroyed. Ping had by then three cameras, a fact indicating that he was a confident and successful photographer. However, the destruction of his cameras put a halt to all picture taking for about three years. The economic pressure on him, now responsible for the support of a wife and baby daughter, was great.

After the disastrous fire, Otto and Clara decided to go west. Clara Ping kept diaries in which she recorded, day by day, the essentials of their life. These diaries are a homely record of work, travel, and expenditures. They are a source of important information about the Ping family and the way people of that time lived.

In March 1912 the Pings had a sale of personal property and went out to South Dakota to work on the farm of Otto's brother Freeman. They probably went by train since no one in the family had an automobile and it would have been impractical to travel by horse and wagon. In any case, Otto, Clara, and baby Irene returned to Indiana for the summer of 1912. In the fall, Clara and Irene returned to Indiana, while Otto left his brother's farm to shuck corn in Illinois. He returned home to Brown County later that year.

The diary kept by Clara Ping for 1915 is filled with details that paint a picture of life in the semiwilderness. Here is her entry for 1 January 1915:

Sun came up clear. Was icy, then went behind a cloud. Gloomy all day. Rained and snowed in late evening and night. Were at home all day. I ironed, Ott[o] made some cases, labeled 16 cases of tomatoes at night. [In Irene's bank] Eggs 8 dozen 35 cents $2.80. Paid Carrie what I borrowed.

On other pages there are references to cutting wood, going to the general store for flour, labeling canned goods, and washing and ironing and hanging clothes to dry inside the house. Prices for purchases and payment received for farm goods are faithfully recorded. Shirts were 40 cents each; a yard of elastic cost 10 cents; and a half bushel of oats sold for 38 cents. At one point Otto Ping was paid the sum of $2.86 for pictures.

Clara and Otto spent a lot of time at Grandma Ping's house. They gave food and shelter to neighbors and relatives. Sometimes friends would come and stay the night. Neighbors would come to help plow or can and sometimes stayed for supper. There were always chores to be done in the house, in the woods, in the barn, and in the garden or fields. Otto hauled manure, plowed, and rode his horse to Pike's Peak for flour or other staples. The sale of eggs and chickens provided an important source of income as did the sale of canned foods. Otto and Clara cut and sawed wood for use in the house. The only source of heat was wood, and a large, cast-iron stove in the kitchen provided heat for cooking and for heating water for the Saturday night baths.

The diaries contain occasional references to Otto's purchase of photography supplies (e.g., 15 February, "developing powder 38 cents, paper 25 cents") and to the locations where he photographed. Sometimes, he went so far from home he had to stay overnight and return the following day. On 9 May, while Clara and Irene went to church, Otto took pictures at Henry Seight's place and also at the home of Edith and Mary Hurley.

Because weather was such an important factor in people's lives, daily reports appear in the diaries. Weather determined whether one worked outside, got wet cutting firewood, or got the wagon mired in the mud on the road. On 22 May Clara Ping wrote, "Rained hard in A.M. I washed and ironed and patched. Otto hauled out some manure. Uncle Jess here for cabbage." In summer the Pings put cheesecloth over the windows, instead of screening, to keep bugs out. They went to camp meetings, shivarees (mock serenades to newlyweds), church, and dinner with other people. An important outing was a trip to a nearby hamlet.

On 3 August 1915 Otto Ping bought his last camera for the sum of $7.35. He would use it and another that he had been able to buy after the fire for picture taking during the next twenty-five years. However, his most memorable photographs of the first years of the century were taken with the cameras that had been destroyed in the fire.

During the course of the following several decades, the Pings continued to live the kind of hard life of unrelenting labor that was typical for that time and for the people of that place. The place in which Irene was born had two rooms, and the outside of the building was protected from the cold by piled up manure. The Pings subsequently lived in a house called the Lemly place, then in the Carmichael place. Their last home was known as the Mellot place, named after the cemetery of the same name, which lies across the road from it.

Bryce, the Pings' second child, was born in 1922. The two children got along well with each other, and they remember their parents with notable warmth. Irene Ping Sluss recalls that her father was gentle and kind, that he spent a great deal of time playing with them, and that he never spanked them. Mother Clara's worst form of punishment was tapping them on the head with a thimble.

Otto Ping · Photographer of Brown County, Indiana · 1900–1940

Otto Ping, Entrepreneur.

Otto Ping was something of an entrepreneur; he and Clara were involved in a number of business ventures. Besides canning and selling farm produce, they sold canning equipment to friends and neighbors. They organized a Home Products Association that offered canning demonstrations to prospects and provided an opportunity to sell the pressure cookers that were used for canning fruits and vegetables. This activity continued at least until Irene was twenty years old. She recalls the seemingly unceasing activity. "He was always canning," she wrote. "His first canning was with a round sealing iron but in the early days there were always tin cans." He had women come to the house to can beans, tomatoes, apples, pumpkins, and other produce. He sold their canned goods not only to individuals, but also to local grocery stores in Columbus, Pike's Peak, and Nashville. At one time he had a canning plant in the village of Pike's Peak. One winter he had an old railroad car filled with canned goods inside a barn. A kerosene heater set fire to the barn, and all was lost.

In the early 1920s Ping bought a Maxwell truck, which he used on a cream route in Indianapolis. He also used the truck to move people's furniture, livestock, or other things. During this time he sold fruit trees, and he always had a garden, pigs, horses, and a milk cow as well.

For a time, Ping was a routeman for Watkins Products, a line of home remedies. One photograph shows him standing beside his sparkling new huckster wagon, dressed in a natty suit and bowler hat.

The poultry business was Ping's most consistently profitable enterprise. He often had from eight to ten thousand broilers in his chicken house, the most conspicuous building on his place. In the 1970s the uninsured building burned, destroying all the stock and the building as well—a sad ending to the only profitable business Ping ever operated.

Irene summed up her father's lack of business ability with this statement: "He didn't know how to make money or how to keep it." He was a chicken rancher, farmer, canner, salesman, peddler of patent medicines, hauler or teamster, seller of canning equipment, corn husker, and farmhand. At the end of his life his house was a ramshackle, one-story, patchwork building that seemed never to have had any adequate upkeep. It needed paint, new roofing, screens, and modern conveniences. In the dusty attic of that decaying house, Otto Ping stored his photographs and negatives. The neglected boxes that held them were water stained and brown and streaked with age.

Otto Ping's Photography.

Until recent years Otto Ping was a virtual unknown in the world of photography, even in Indiana. He was born in a remote part of Brown County, Indiana, and he remained there all his life. He had no interest in extending his photographic reputation beyond the area in which he lived and traveled. His work was preserved only by accident.

Ping was self-taught, isolated, undereducated, and naive in the arts. He was unaware of the social and historic value of the work that he had done. His photographic images are not important because of technical finesse. Rather, they are significant because they are an incomparable visual record of a specific period in the life of a small segment of Indiana.

The part of Brown County where Ping spent his life has little relationship to the Brown County that is now such a mecca for tourists. Van Buren Township, Brown County, is an area of south central Indiana that is quite beautiful, a place that has attracted painters, writers, and poets. But it is not particularly suited to agriculture or animal husbandry. It is hilly, wooded, remote, and soil-poor. The back roads of that part of the county are meandering, unpaved, and narrow. In spite of its limitations, it began attracting settlers in the early nineteenth century. They

farmed on a limited scale, raised cattle, horses, and swine, and managed to eke out a living. The villages that were bustling and filled with promise in the late nineteenth and early twentieth centuries are now, for the most part, deserted. In another two or three decades, many of them will probably have disappeared, leaving behind little more than some stone foundations and remnants of chimneys that have been without fires for half a century or more. In the 1950s and 1960s life was still left in many of the hamlets, but neglect and atrophy had left an imprint on most. The Brown County that Otto Ping photographed early in the twentieth century was at the peak of its virility. On his glass plates Ping etched haunting scenes of a lifestyle that was slowly drifting toward extinction.

Otto Ping and his work are inseparable from both his place in the geography of Indiana and the small window of time that he occupied. Ping was a "local" who made a place for himself in Brown County and adjoining counties, primarily as a photographer of people. He was, first of all, a portraitist, photographing individuals, couples, family groups, and larger gatherings. Many of the formal portraits showed people posed in front of hanging blankets and quilts.

Because of the sparse population in his own township, he found it necessary to go farther from home. In a sense, he became an itinerant photographer at a time when cameras were still "newfangled" gadgets that few people owned. A generation before Ping came along, artists would travel from farm to farm, making drawings of individuals. The camera quickly made that kind of transient portrait artist obsolete.

It should be no surprise that Ping made many pictures of members of his own family. Besides portraits, he photographed people at their places of occupation or affiliation: groups posed stiffly in front of churches, schools, lodge halls, and even sawmills. He also photographed people at their leisure, children playing, a few still life subjects, and a small number of landscapes. In addition, he took

many photographs of the dead. These were commissioned works made so that family members might have one last image of the deceased. Some were elderly people; others were children or infants.

No images of weddings or christenings by Ping have survived the passage of time. Irene Ping Sluss remembered that her father took pictures of her wedding in 1941, but she could remember no others.

Otto Ping photographed people and subjects that he was hired to record, and there is a clear, documentary quality in his images. His work is stark and pragmatic and reflects a lack of awareness of the beauty and majesty of nature. This was probably the result of spending too many years deep in the woods and walking behind a horse and plow. Because of his rural isolation, he remained a man untainted by influences. His art was that of the innocent.

By the time he stopped taking pictures, about 1940 or 1941, Ping had been deeply involved in photography for a period of about four decades. The reasons that he stopped are not difficult to reconstruct. By the 1930s the small, portable Brownie-type cameras had become relatively inexpensive and available. Most families had some kind of small box camera and took their own snapshots. Average people could take pictures of their children, vacations, cars, pets, and homes. Those who wanted formal studio portraits had their choice of local studios. Even small towns had photographic studios for portraits and for pictures of such occasions as weddings, baptisms, and so forth. Traveling photographers, like Otto Ping, were sliding into extinction along with blacksmith shops, saddleries, stables for hire, and a number of other institutions. Gradually, the peddlers were replaced by motorized delivery trucks, and the horse gave way to the automobile. The period of 1920 to 1940 probably witnessed the demise of most of the old socio-economic structure that revolved around the horse.

Otto Ping was a natural chronicler of the last period of pioneer life, but when times changed he put away his camera and stored his negatives and prints in the attic of his

house. For the remaining thirty-five years of his life he did other things. Little did he know what he had managed to record and document during his four-decade career as a rural photographer.

In his last year of life Otto Ping, then in his nineties, lost his voice. He seems to have become what is known popularly as senile. Clara had a hard time keeping him inside the house at night. On a cool night in October 1974, he got out of the house and wandered off into the woods. Seventy-five people came to help look for him. He was eventually found and saved from death by exposure. Not long afterward he was going down the ladder in the barn and fell when a weak rung gave way under him. He broke his back and was taken to the hospital. He was later transferred to a nursing home where he died in 1975.

Ping would, certainly, have assured anyone that his was a good life. Some might say that his life was tragic because it was so filled with business failures and relative poverty. The one thing that he did well, take photographs, brought him little in the way of money and nothing of recognition. He made timeless images of the people of Brown County, their homes, cabins, families, and work. He took pictures of their living and their dead. His legacy to us is a treasury of images that records the hardships, joy, pride, and labors of a group of people who were still pioneers.

The Photographs of Otto Ping

P ortraiture has been, historically, one of the main- stays of artists. From the formfitting death masks of Egyptian pharaohs to the marble Roman busts, through the elegant oil portraits by Renaissance masters and the aristocratic portraits of eighteenth-century nobility, the focus has been the same. The artist seeks to create a likeness that suggests the basic character and per- sonality of the person represented. The demand for such likenesses of people carried over into the world of photog- raphy. Portraits were a staple in Ping's repertoire and the foundation of his career with the camera. He made por- traits of individuals, couples, siblings, and family groups. He also made many large group pictures that showed stiffly lined-up rows of schoolchildren, members of church con- gregations and lodges, and workers in their workplaces.

The faces that look out at us in the photographs are often eloquently descriptive. Often, the visages of the older people show the scars of years of toil and hardship. They are etched with the physical manifestations of hardiness, determination, grit, and sometimes of melancholy. The images of self-conscious old men evoke the hardships that were endured by the early Indiana settlers.

In most cases the sitters who posed for Otto Ping go unnamed. However, the identities of those individuals are of little importance. The importance is cumulative, not individual. The portraits are characterized by starkness, simplicity of pose, rigidity, and plainness of the back- ground. Lighting is functional, Spartan, and unforgiving. Ping often posed his subjects in front of badly hung sheets and blankets; he used few props, if any. The result is that the portraits have a neutral setting with nothing to detract from the subject. The lack of special lighting, reflectors, secondary sources of light, and other devices makes the portraits brutal in their scrutiny.

Otto Ping repeatedly displayed the importance of work in the Indiana hill region in his portfolio of photographs.

Because of the relative isolation of the area, every farm family had to be as self-sufficient as possible. The family produced most of its food and many articles of clothing. Still, some needs required specialized services and work- places. These included the mill for milling grains into flour, the blacksmith shop for ironwork, the distillery for spirits, the harness shop for leather goods, the sawmill for finished building materials, and the general store for other items. These pictures suggest the pride that was taken in labor in this society and the strong emphasis that was placed on work.

Horses appear in many of Otto Ping's photographs: pulling courting couples in fancy buggies, harvesting or threshing machinery, farm wagons laden with grain, plows, sleds with heavy slabs of stone for building, harrows, ped- dlers' wagons, and many other things. The horse was a four- legged powerhouse that was essential on the farm or in a rural community.

The peddler and his horse and wagon were of great importance to rural households in this, and earlier, periods in American history. Peddlers usually had routes and car- ried a variety of products that a household would need, from bolts of material to pots and pans, coffee, flour, sugar, spices, and scissors. Their arrival was an event that was cel- ebrated by the farmwife and children.

In the period when Otto Ping was practicing his art, he was called upon to photograph the dead. In rural Indiana when cameras were relatively rare, a photograph of a deceased person might have been a family's only photo- graph of that individual. These images are primarily of the very young and the very old. The pictures of dead babies, dressed in baptismal gowns, are particularly moving. In the late nineteenth and early twentieth centuries it was the custom in America to have the dead on display in the home, with a black wreath on the door. It was then that Ping photographed his subjects for the last time.

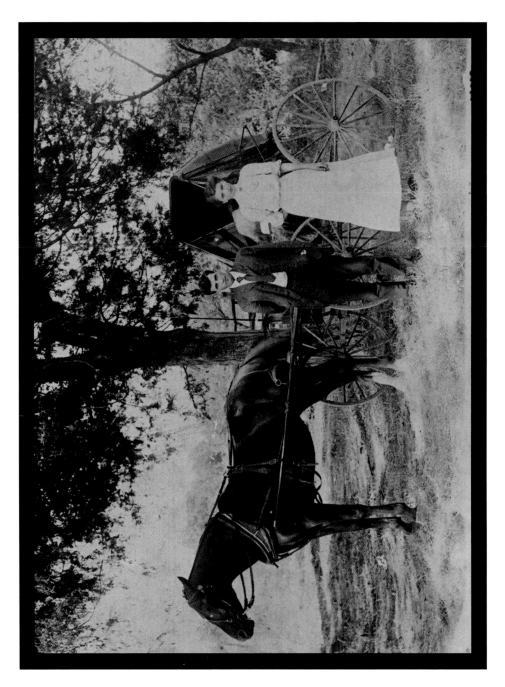

Otto Ping and Clara Ewers, Summer of 1906.

This is a picture of the photographer standing beside his sweetheart, Clara Ewers, on their second date. Clara was only fourteen at the time. Four years later, they were married. It is likely that the photograph was made in the yard of the Ping family house.

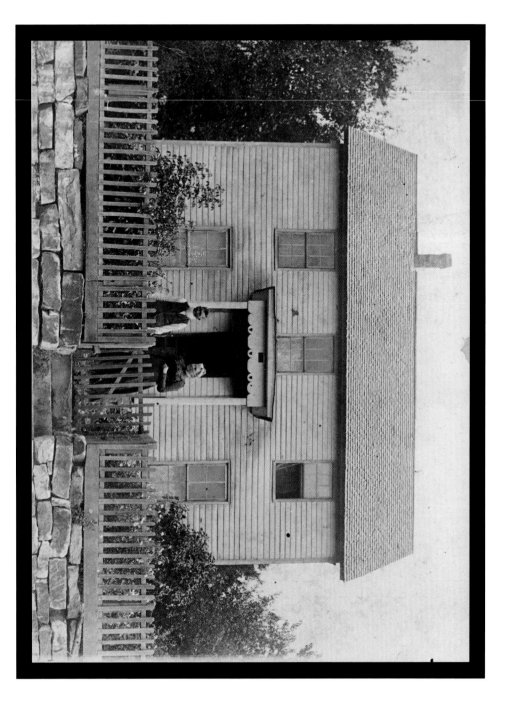

Jackie Harden at Stone Head.

Scrawled on the back of the photograph are the words, "Jackie Harden at Stone Head." This is one of the few houses photographed by Ping that displays any embellishment or ornamentation. Note the scalloped edge of the porch facade.

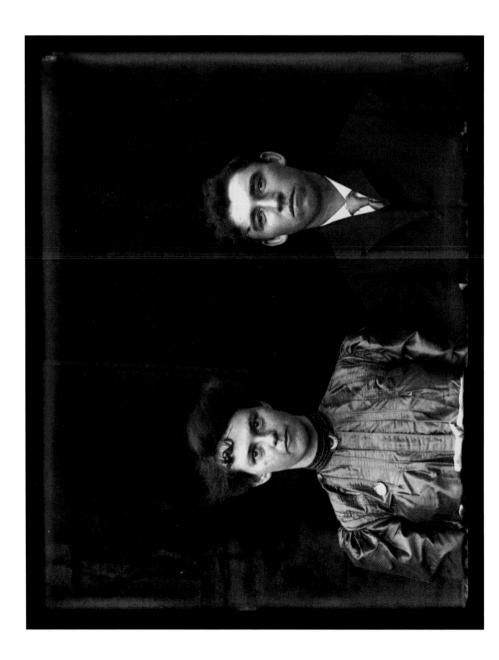

Young Couple.

The faces of the young display
vigor along with a certain
pragmatic sternness.

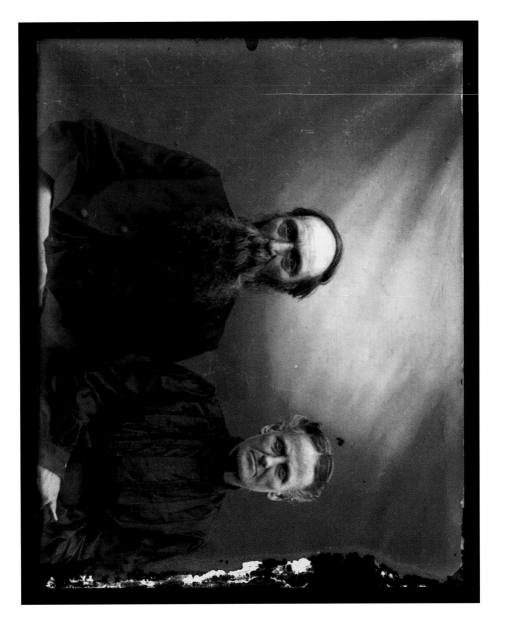

Old Couple.

The faces in the early portraits by Otto Ping are marvelously evocative of hardship and deprivation as well as of strength of character. This double portrait of an old, bearded man in a black frock coat with his wife in her taffeta dress with a high collar is an excellent example. There is an austere mien to those faces that is almost biblical.

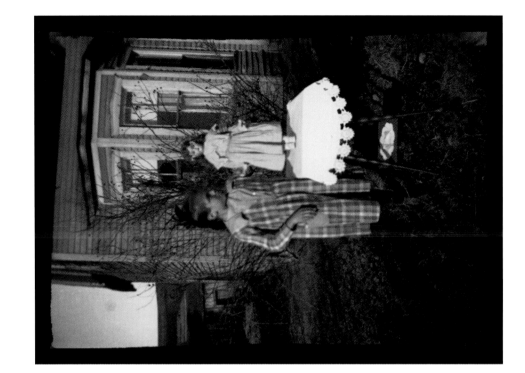

Irene Ping and Her Doll.
ca. 1922.

Irene, about age eleven, is hold-
ing her doll, Helen Ruth, on a
table in the yard of a house in
Poplar Grove Ridge.

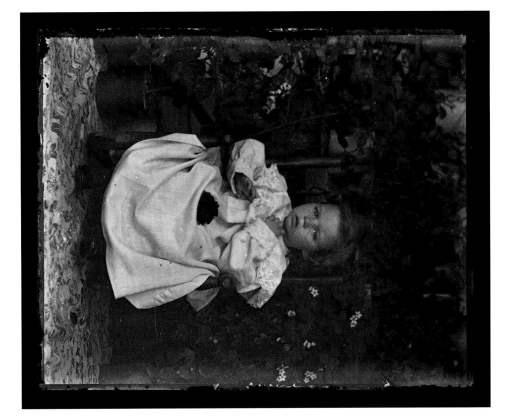

Small Girl with Rose and
Rocking Chair.

The child in this charming
portrait seems to be scowling,
perhaps because she has waited
too long for the photographer to
arrange his composition. The
potted plants behind her hide
most of the back cloth. The
lighting was subtly handled.

Baby in Baptismal Dress.
This infant portrait shows the
child in a long and elaborate
baptismal dress. The child has
been propped up in what
appears to be an armchair with a
coverlet to hide the pillows.

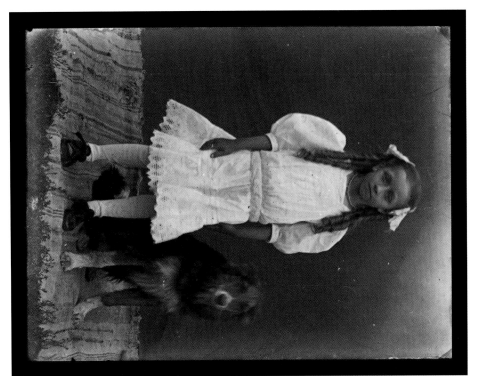

Portrait of a Girl and Her Dog.

This portrait of a girl and her dog is an example of one of the standard poses Ping used with children. Like most of his formal portrait studies, the pose is frontal and relatively rigid. The child was obviously dressed in her "Sunday best" for the portrait. The inclusion of the dog adds warmth and charm to the image.

Boy with Large Collar.

This young child stands stiffly before a fabric that is attached to weatherboarding. His high-top shoes are dusty and poorly tied. His jacket (too small for him) was in all probability a hand-me-down. The ornate collar seems too frilly to be a part of this lad's attire. This was clearly not a happy occasion for the boy.

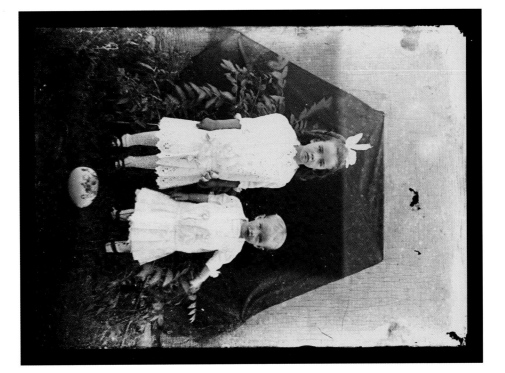

Two Children and
Easter Egg.

The two children in this portrait
stand with serious expressions
before the camera. The
girl is probably standing beside
her younger brother. Both are
dressed in ornate dresses of
eyelet material with lace stock-
ings, typical of the period. The
elaborate Easter egg suggests
that the photograph might
have been taken after church
services on Easter Sunday.

17

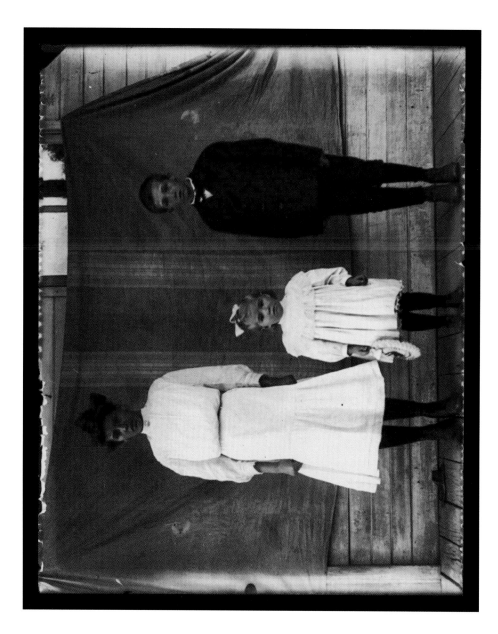

Three Children.

The V configuration of figures
in this photograph focuses atten-
tion on the small girl in
the middle.

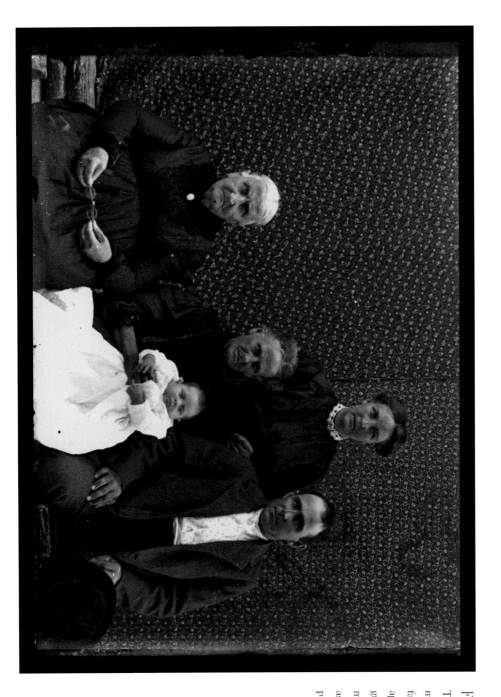

Four Generations.

This photograph is one of the most successful of Ping's smaller family groups. The group appears to be made up of the great-grandmother, grandmother, parents, and baby. The asymmetrical arrangement is particularly effective.

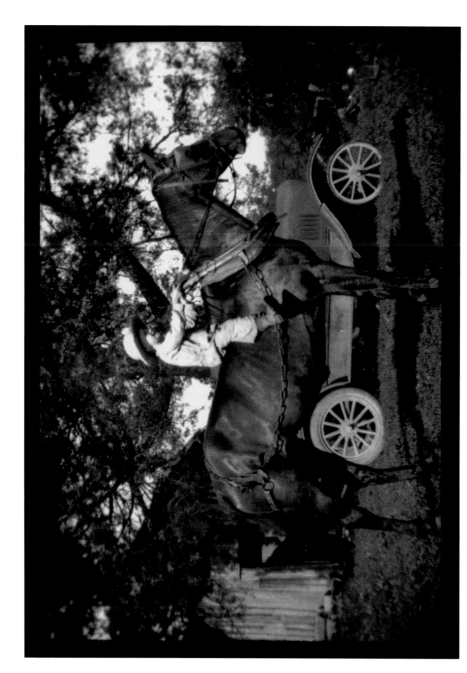

Bryce Ping on a Horse, ca. 1925.

The horse in the photograph is harnessed with collar and blinders. In the middle ground there is what appears to be a Model T Ford light truck. The front wheels have solid rubber tires while the rear ones, much larger, have pneumatic tires. All wheels on the vehicle have wooden spokes.

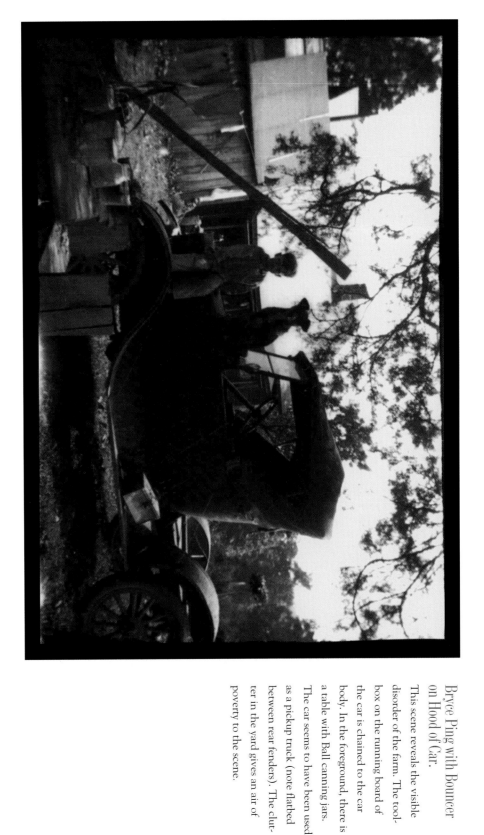

Bryce Ping with Bouncer on Hood of Car.

This scene reveals the visible disorder of the farm. The tool-box on the running board of the car is chained to the car body. In the foreground, there is a table with Ball canning jars. The car seems to have been used as a pickup truck (note flatbed between rear fenders). The clutter in the yard gives an air of poverty to the scene.

Carrie Ping, ca. 1910.

The rough beauty of the land is clearly shown in this photograph. Carrie Ping, Otto Ping's younger sister, sits on part of the stone foundation sections of the Logan Ping place. Stones such as these were easily quarried in the area from creeks and rock outcrops. Carrie's bonnet is of the type still worn by farm women in many parts of the country.

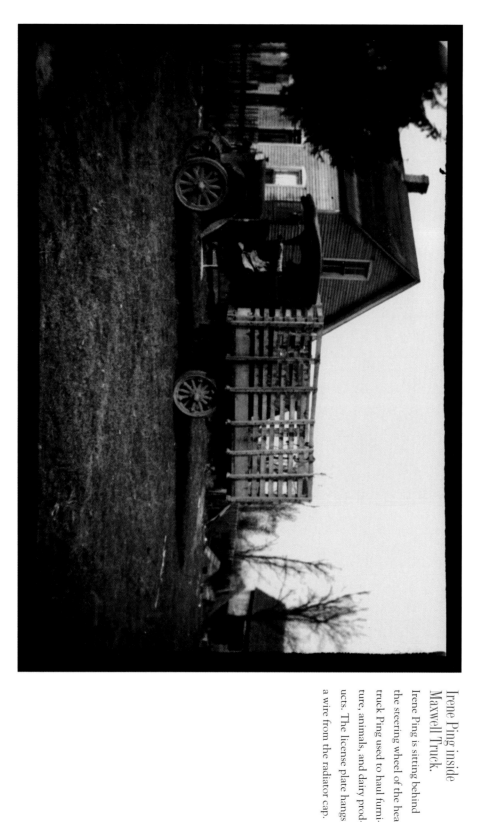

Irene Ping inside Maxwell Truck.

Irene Ping is sitting behind the steering wheel of the heavy truck Ping used to haul furniture, animals, and dairy products. The license plate hangs by a wire from the radiator cap.

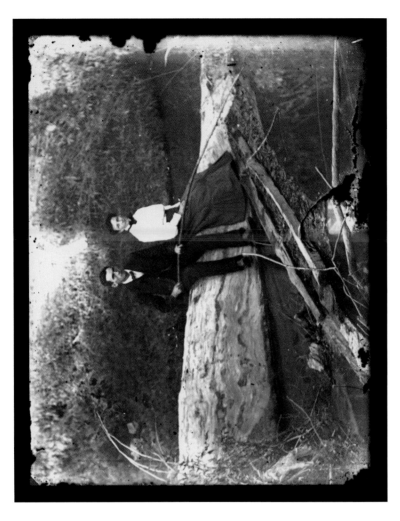

Couple Fishing.

This placid scene features
a young couple dressed more
appropriately for a social
event than for fishing in
a quiet stream.

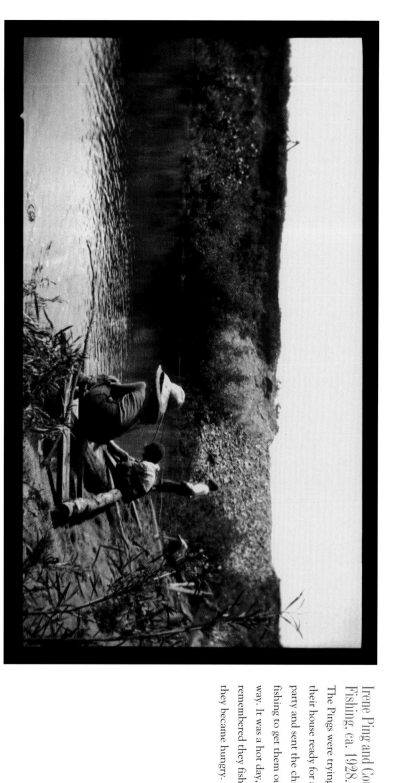

Irene Ping and Cousins
Fishing, ca. 1928.

The Pings were trying to get
their house ready for a birthday
party and sent the children out
fishing to get them out of the
way. It was a hot day, and Irene
remembered they fished so long
they became hungry.

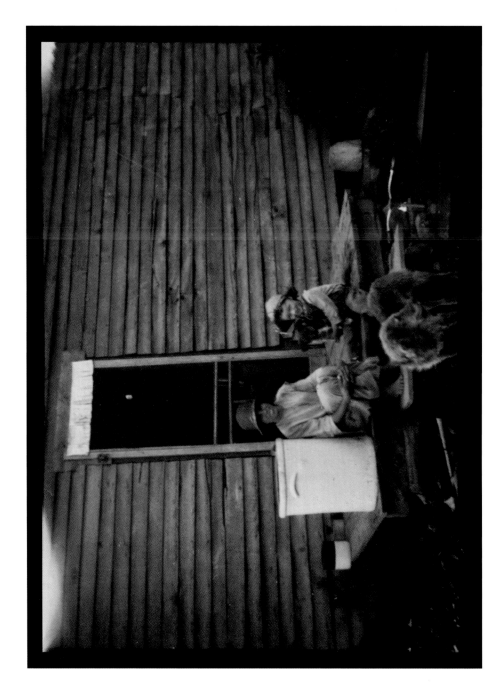

Irene and Bryce Ping and
Trixie on Stoop of House,
ca. 1924.

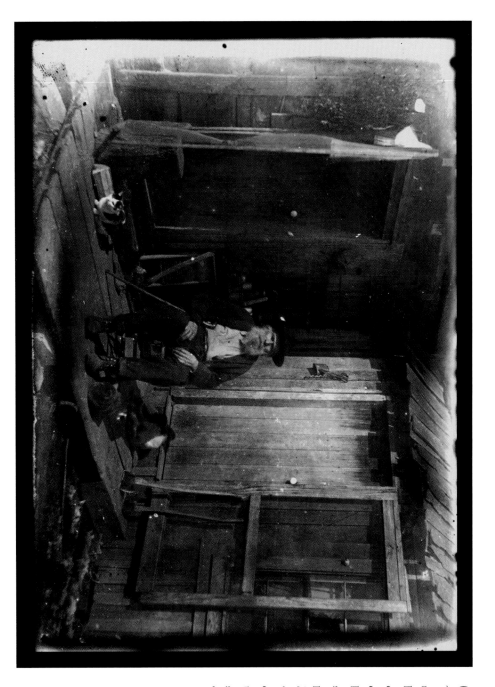

Old Man with Beard.

This portrait shows an old man, seated on the porch of his house cluttered with many objects and animals—cat, buckets, washboard, hound dog, kitten, and other things. Ping submitted this photograph for publication to the Columbus *Republic* newspaper in 1971, when he was eighty-eight years of age. A handwritten note on the edge of a clipping in the possession of the Ping family says, "Valentine Penrose."

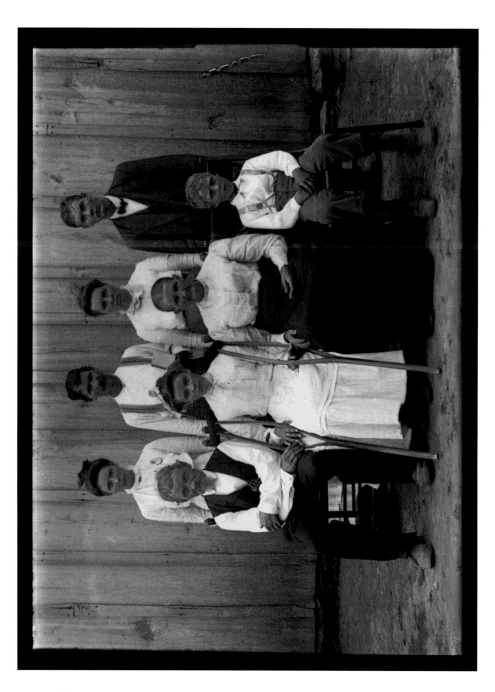

Family Group with Girl and Crutches.

This apparent family shows what may be grandparents, parents, and grandchildren. The faces reveal a strong resemblance.

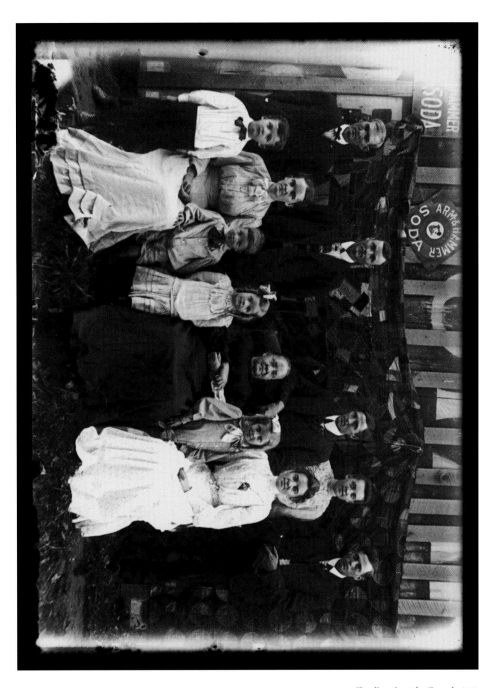

Large Family Group.
The seated matriarch in
this group is gowned in black.
The four younger men and one
woman at rear, spaced rather far
apart, serve as visual anchors
for the composition.

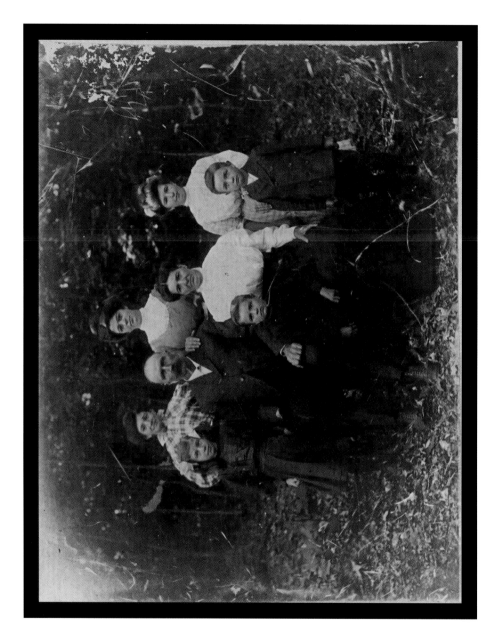

The Barker Family at
Beck's Grove Ridge.

Of nine children born to the
Barkers, only three survived to
adulthood. The little boy stand-
ing in the front row at the right
end was dead before the photo-
graph was printed. The Barkers
engaged Ping to photograph him
one last time lying dead in his
bed (p. 69).

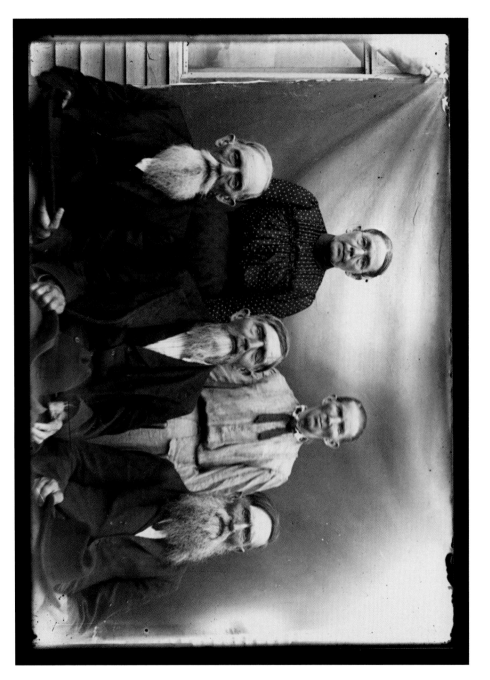

The Old Folks.

This group of five people is surely from the first years of the century. The three bearded patriarchs and the two younger women standing behind them bear a strong family resemblance. One guess is that the three men are brothers, photographed in the fullness of their years. The bearded man at center appears to be blind, with one eye drooped closed and the other staring blankly ahead. The cumulative effect of lives spent toiling in the wilderness is stamped irrevocably in these magnificent faces.

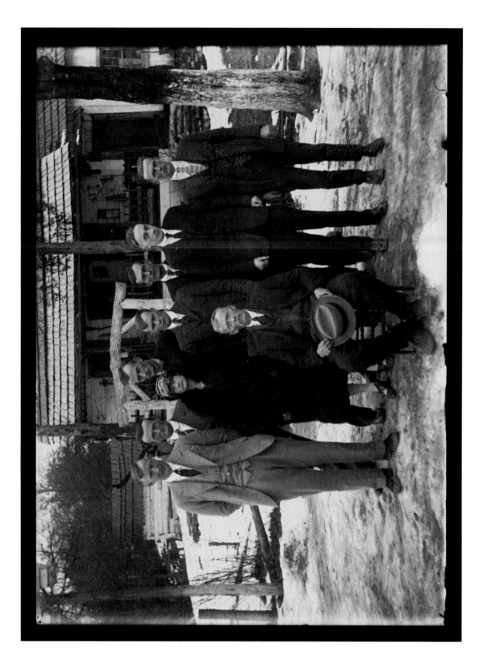

Eight Men and One Woman.
This somber group could have been photographed immediately before or after a funeral, judging from the sobriety of the individuals and the formality of their dress. The style of clothing suggests that the picture was made in the late 1920s.

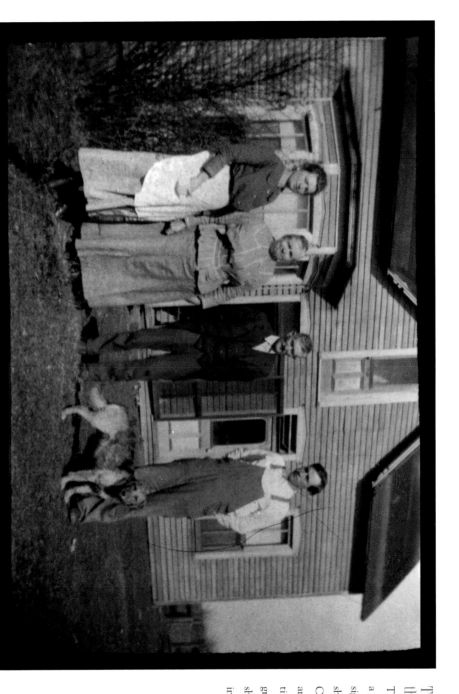

The Pings and
the Carmichaels.

This photograph, printed from
a glass negative (which shows
signs of age and deterioration),
shows (l to r) Clara Ping, Mrs.
Carmichael, Mr. Carmichael,
and Otto Ping. This is a rela-
tively rare picture of the photo-
grapher wearing a long-sleeve
shirt, tie, and bib overalls. Also
included is Trixie, a family pet.

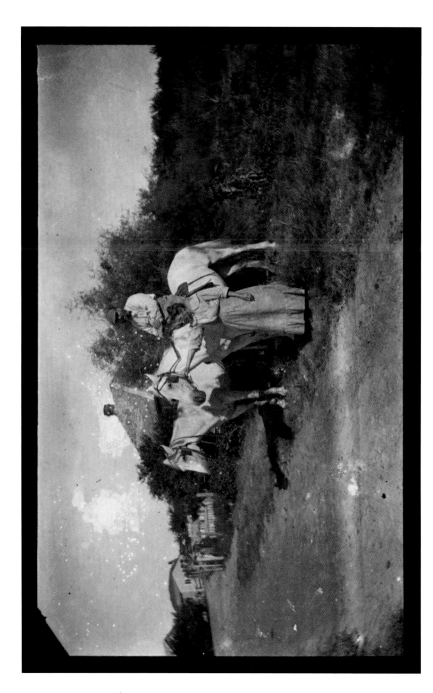

Couple with Team of White Horses.

This image graphically shows the ruggedness of life lived by the people of the Brown County region. The house and out buildings are simple. The horses are plow animals that have obviously been worked hard and may be as old as fifteen years. The picture has a documentary quality that is strangely moving.

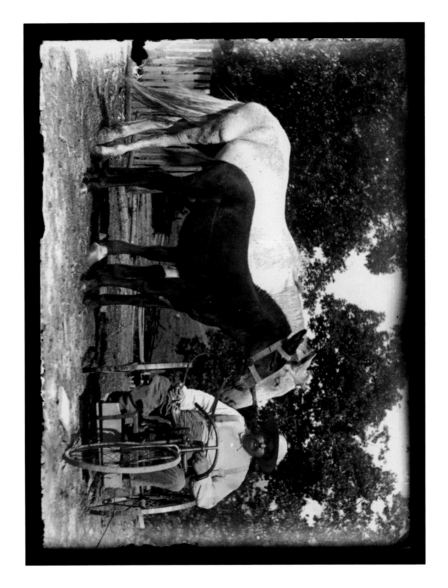

Man in Wheelchair and White Mare with Black Foal.

A mare and her black foal (a mule) stand and watch a heavy-set man in a most unusual vehicle. The man appears to have lost his right leg, and perhaps his left foot. His makeshift wheelchair was evidently made out of the front wheel and handlebars of an early model bicycle. The back wheels appear to be metal and might have been taken from a light farm cart. The lumpy character of the visible rear leg of the old mare shows that she has been worked hard.

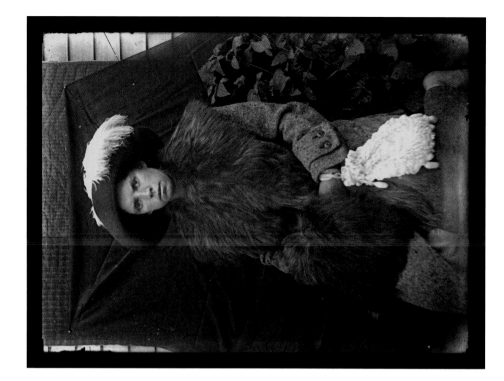

Young Woman with Fur.

One of the truly enchanting portraits is this image of a young woman kneeling in front of a blanket. She is a handsome woman, elaborately dressed in a heavy woolen coat with a large fur collar. She carries a beaded purse on her arm and has hidden her hands in a fur muff.

The hat she wears is decorated with a large white feather. The coat and other elements of her costume seem expensive and stylish, paradoxically, on a young woman without shoes.

Young Woman.

This pretty young woman differs from most of the other portrait subjects in that she is not sitting with a stiff, frontal pose in front of the camera. Her upper body is turned at an angle as she looks toward us over her shoulder.

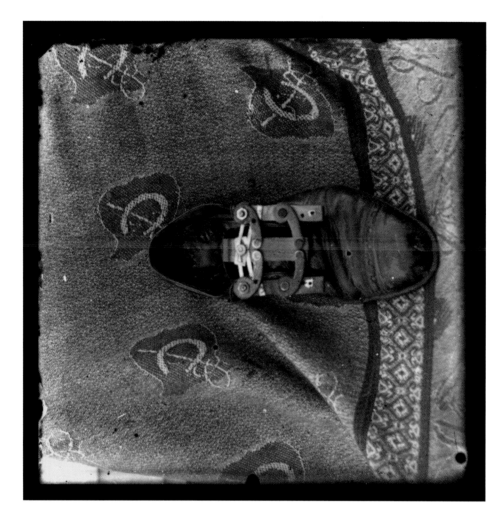

Old Shoe with Latching Device.

This well-worn shoe is unique in that it has a most unusual device as a fastener. There are no laces, buttons, or hooks, but rather a set of four arm-like wooden devices which are held in place by nuts and bolts. A companion photograph shows the shoe-closing device in an open position. The pair of photographs illustrates how a curious invention worked. Perhaps the pictures were made to submit to the patent office.

There is a chance that Ping himself was the inventor. His daughter said he often worked on inventions and, at one point, was working on a calculator.

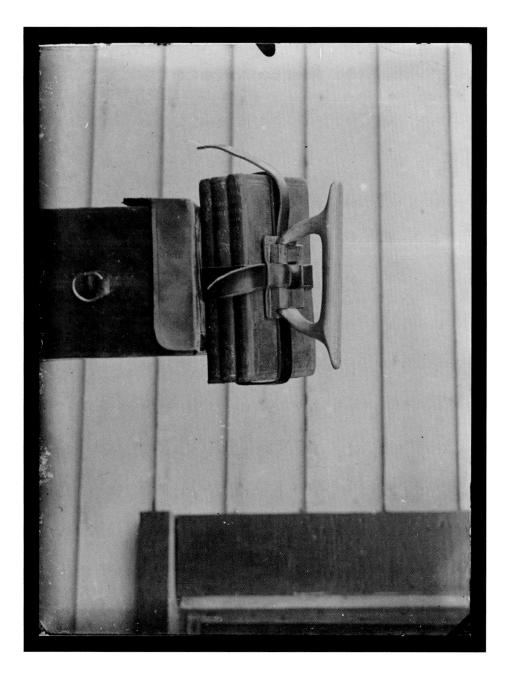

Books, Camera Case, and Book Carrier.

The object in this photograph seems to be a book carrier complete with leather straps and a hand-carved wooden handle. The box under it is Ping's camera case, used here as a platform for making the photograph. Perhaps it, too, was the work of Ping.

Ewers Family at the
Sawmill, ca. 1906.

The man holding back the
team of horses is Clara Ewers's
father, Sam. The building, with
its straight front step, looks new.
Though there is some informal-
ity to the photograph, it seems
to have been posed. To the
right, a doll perches on top
of a stump.

George and Stella Ewers in the Woods near Shoals, ca. 1906.

This photograph shows the site of the sawmill operation run by the Ewers family. The two young people standing by the tent are Clara Ewers Ping's brother and sister.

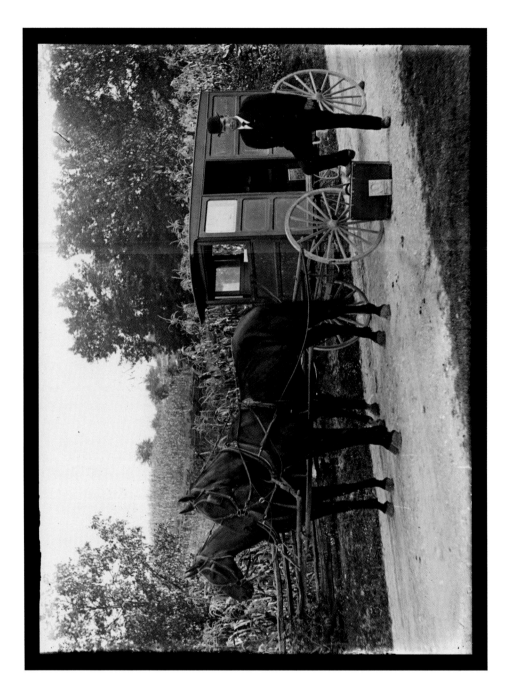

Peddler and Watkins Product Wagon.

The Watkins company made products primarily for domestic and personal use, targeted for women at home. Otto Ping, who appears in this photograph, sold Watkins products as one of his many business ventures.

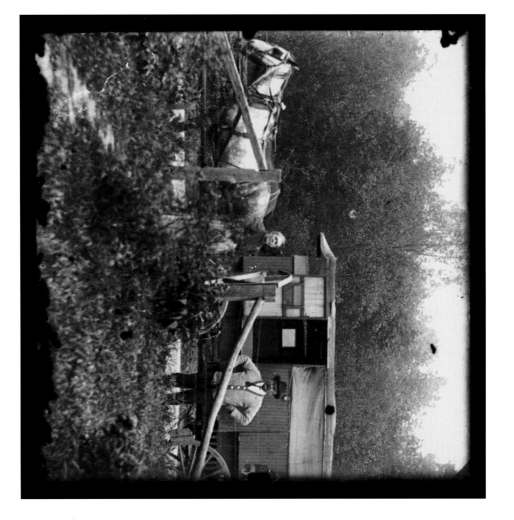

Peddler Van Sullivan and Client.

This spotty image shows an unidentified woman standing at her front gate with a peddler believed to be Van Sullivan. Sullivan was a well-known huckster in the Brown County area. The wagon looks as if it might have been converted into a huckster wagon from an ordinary spring wagon, like those in common use on farms at the time.

Earl Ping in Woods,
ca. 1906.

The youth seated on the
broken tree limb is Earl Ping,
the youngest of Otto Ping's
siblings. He is well dressed,
with conspicuous gold watch
chain and fob.

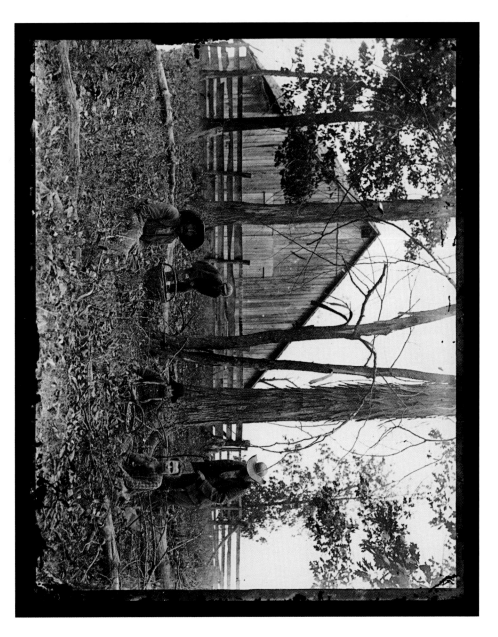

Gathering Nuts.
This photograph, taken early this century, shows William Ping, uncle of the photographer, standing at right. With him are four younger people, who are taking a rest from their nut gathering. The nuts, being gathered in homemade baskets, supplement the diet and shelling them gives young and old something to do inside during the long, cold days of winter.

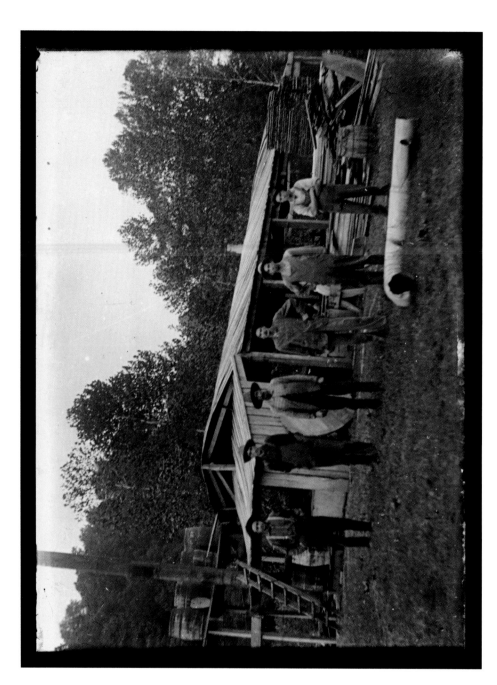

Sawmill Group.

This is one of many photographs Ping took at sawmills. The buildings are rough and functional, and the scene is filled with apparently makeshift structures. This picture contains a crude ladder, a long section of a smokestack, and a platform holding several barrels.

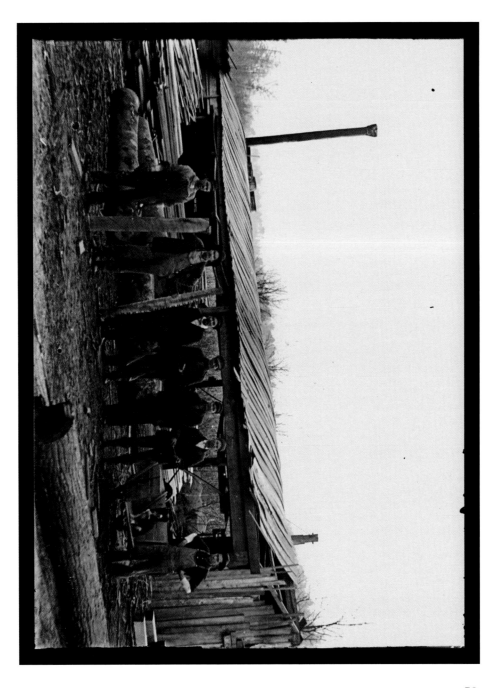

Seven Men at Sawmill.

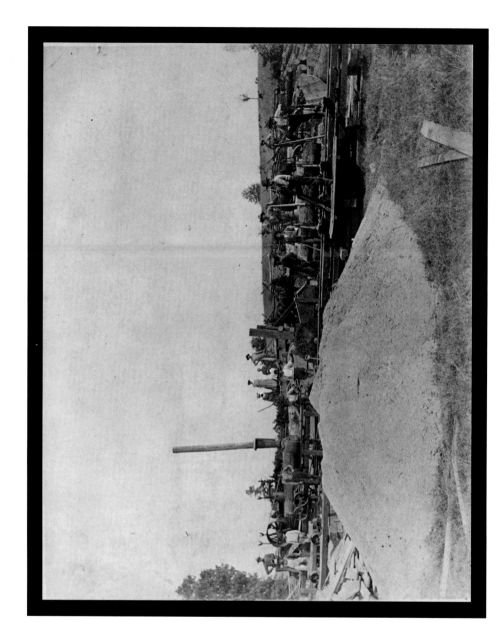

Sawmill Scene.

This image shows a sawmill operation, as evidenced by the sprawling mound of sawdust, the large blade, and the steam engine used to operate the saw.

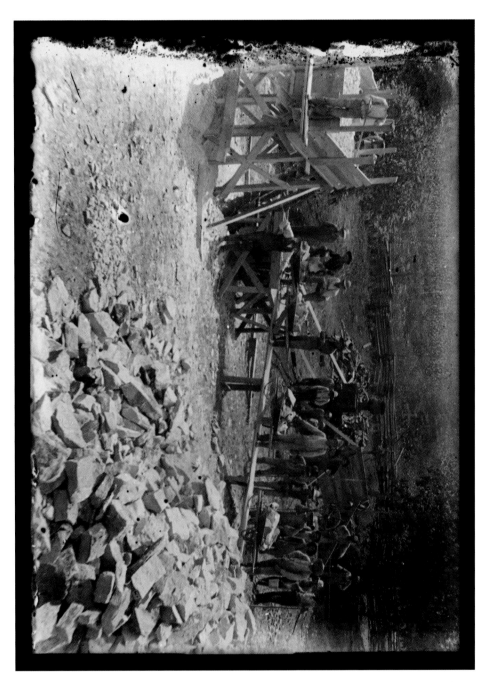

Stone Pulverizing Scene with Steam Engine.

It appears that the rocky chunks in the foreground of this photograph are being hauled by wheelbarrow across the ramp to a receiving platform at the left. The steam engine powers a stone crushing device at the left of the center of the photograph. The crushed stone is then hoisted to the platform by means of the conveyor belt. From the top of the platform the end product can be shoveled into farm wagons for transport elsewhere. The material being crushed in this scene is probably low-grade limestone utilized in the manufacture of cement or plaster and brought from quarries in Bedford or Bloomington.

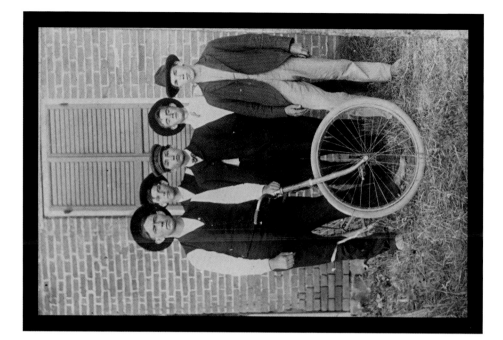

Boys from Leesville.

Otto Ping had no explana-
tion for this picture except
to say that the boys were
from Leesville.

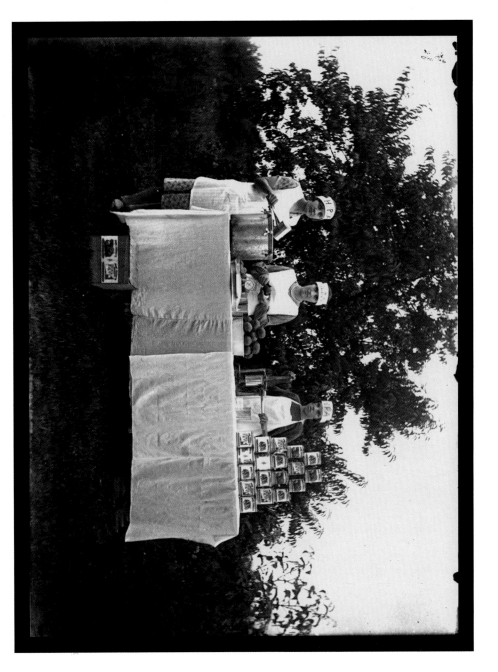

Home Products Association Display, ca. 1927.

In this picture three members of the Home Products Association are displaying their wares. Left to right are Mildred Lackey, Gladys Clark, and Irene Ping. The large object at the left on the tabletop is a pressure cooker used for canning homegrown fruits and vegetables. Typically, home canning was done in glass Mason jars with metal screw-on caps and a rubber ring. The canned products shown in this photograph were preserved in metal cans using a different system. The Home Products Association was conceived and promoted by Otto Ping in 1926.

Family Standing in Front of House.

Many photographs in the Ping Collection depict families posed in front of dwellings. In these pictures the structure itself is as important as the individual family members. A dwelling, be it house or cabin, represents status, accomplishment, work, permanence, and dignity. This young family displays great pride in what appears to be a new home.

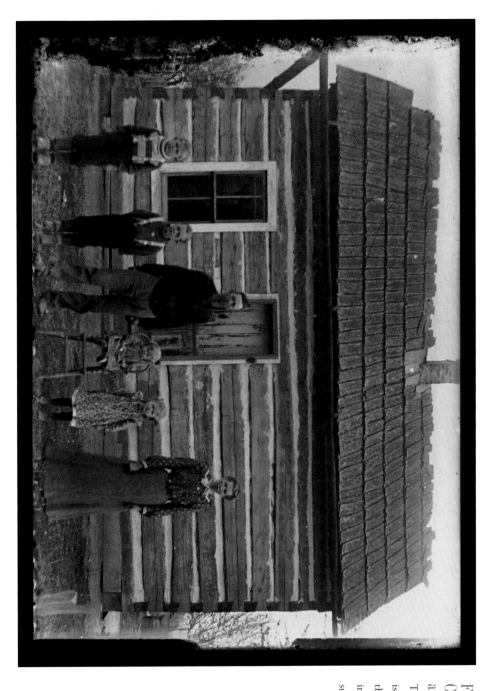

**Family Group with
Cabin, Four Children,
and High Chair.**

The cabin behind this family
is simpler and apparently older
than the home in the preced-
ing picture. The jagged roofline
suggests greater age.

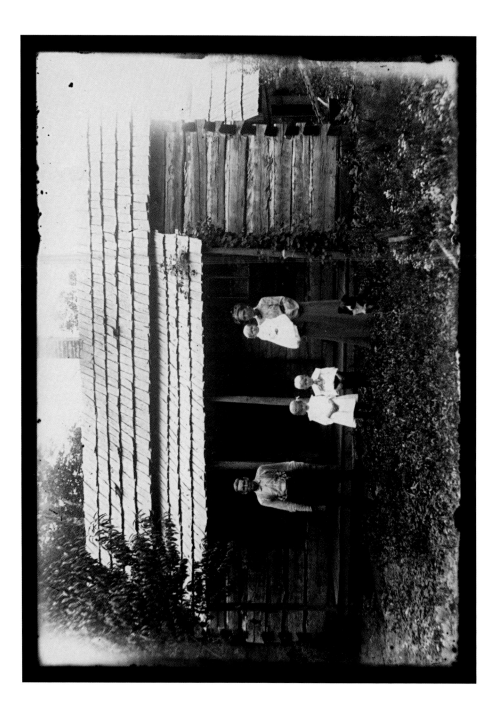

Family Group and
Log Cabin.

This family's log cabin is functional and plain. The faces of the father and mother display the determination of pioneers.

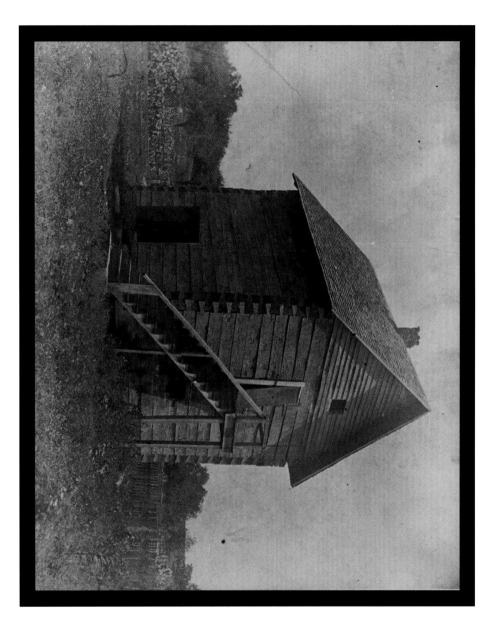

Old Brown County Jail,
Nashville, ca. 1905.
As long ago as the 1930s when
the author visited the jail, its
only function was as a tourist
attraction. The cells were
tiny cubicles with no comforts
or privacy.

Fishermen in Woods
by a Lake.

In this bucolic scene the figures
are subordinate to nature. The
still silhouettes of men on the
embankment seem dwarfed by
the large trees in the setting.

Landscape with Distant Houses.

Although Otto Ping is known primarily as a portrait photographer, he made many other kinds of pictures. This landscape is reminiscent of landscape paintings of the time. The distant backdrop of a grove of trees, the geometric shapes of the houses and outbuildings, the large tree on the right, and the textured foreground produce a balanced and serene composition.

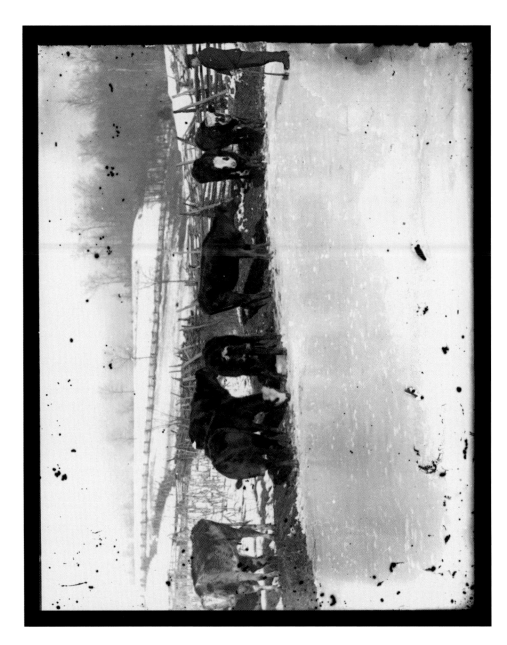

Cattle in the Snow.

A solitary man standing at
the right of the picture watches
a few cattle in the barnyard.
They stand on a narrow patch
of ground that has been exposed
as the snow melts. The sparse-
ness of the photograph is its
most salient feature.

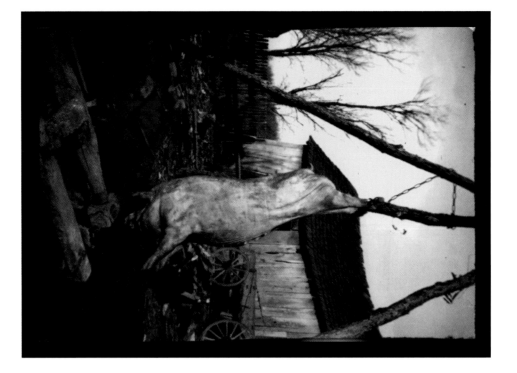

Hanging Hog Carcass.
This photograph of a butchered
hog carcass, suspended from
a tripod fashioned of tree limbs,
was made in the back of the
Ping place. Ping said that shortly
after the picture was taken the
carcass fell on one of the men
and nearly killed him. A carcass
of this size would have weighed
nearly a thousand pounds. The
butchering of a hog was a major
undertaking on farms. It was
a long, hard process that began
early in the morning and lasted
until dark. Everybody in the
family, except small children,
was involved. Virtually all parts
of the animal were used.

Barnyard with House
and Poultry.

There is an indisputable bleak-
ness in this image. The farm-
house and nearby barn look
as if they had never been
painted. A pile of timber in the
foreground separates the barn-
yard from the rest of the yard
area. There is no human figure
in the picture, contributing
to the loneliness conveyed by
the scene.

Building with Boy
on Horse.

The wooden building with its
missing boards and decaying
wood-shingled roof is the epit-
ome of decay and abandonment.
A member of the Ping family
said that this was probably the
building where Otto Ping was
born, perhaps explaining Ping's
interest in it.

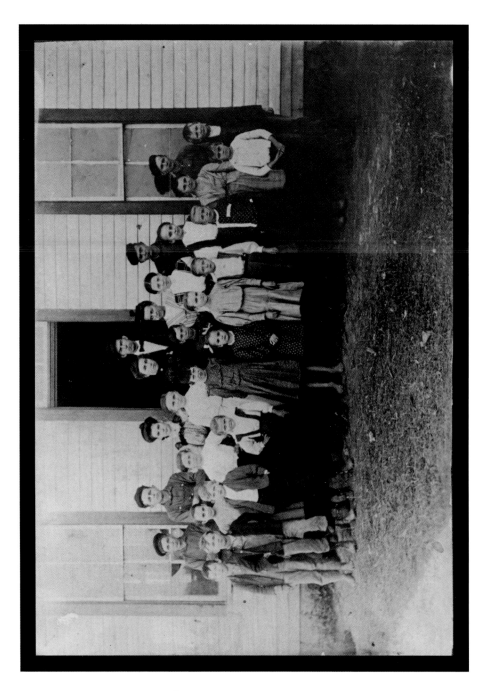

Christiansburg School.

Because of the wide range of ages of the pupils, this photograph very likely shows all the pupils enrolled in the various classes of the Christiansburg School. The tall man standing in the door is the teacher, Harley Carmichael, and the two women in the back row might have been teachers as well.

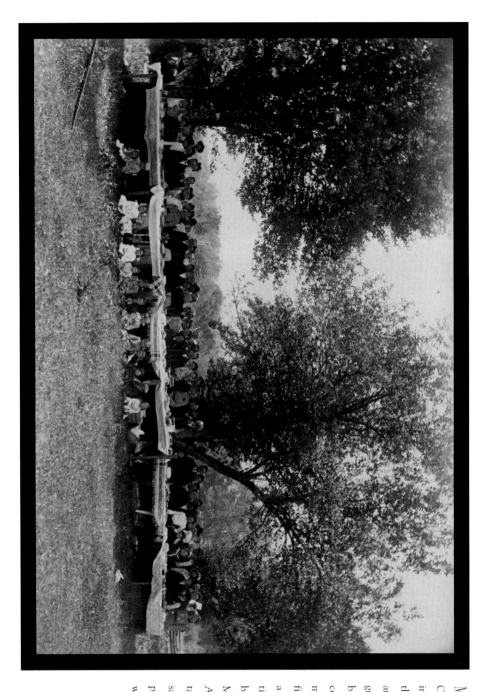

Mr. Mabe's Birthday Party.

One might assume from the images in the Ping Collection that life at this time was all work and no play. However, large groups did gather for special birthday parties. At Mr. Mabe's celebration, there are approximately eighty-five adults and fifteen children gathered by half a dozen long tables. The inscription by the photographer on the back of the print said, "Taken at Mr. Mabe's house at Stone Head. A birthday dinner." When Ping talked about the gathering, he said, "I got my dinner. Lots of people bought pictures. There wasn't any TV."

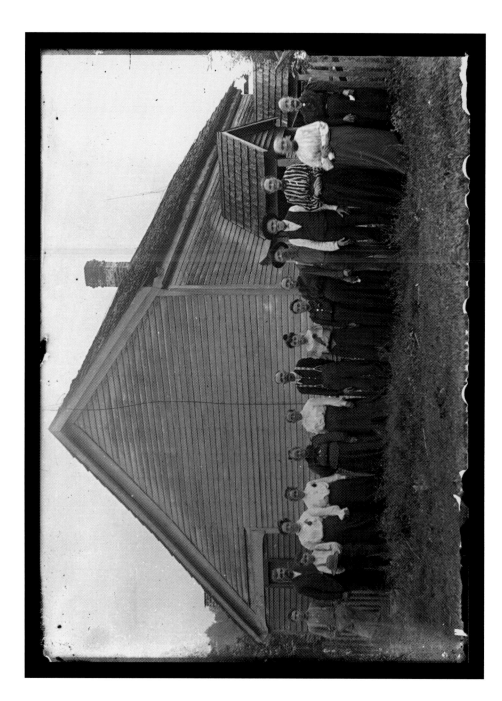

Group Standing in Front of Frame House.

This group of sixteen people is made up of ten women, four men, and two boys.

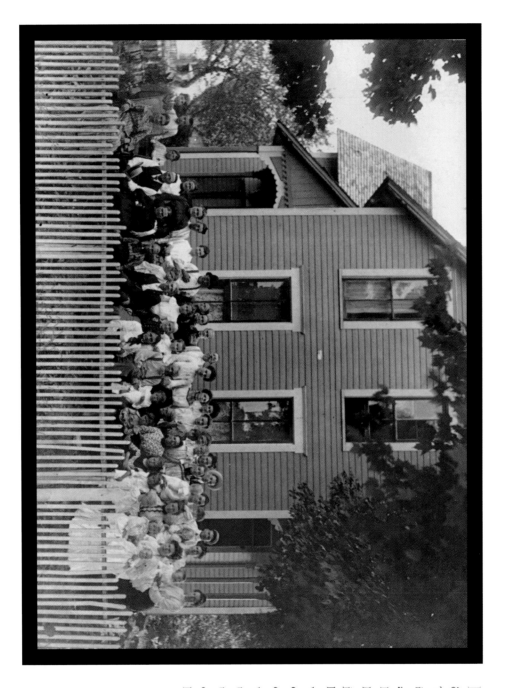

Billy Mabe's Reunion
at Stone Head.

This gathering includes fifty-four
individuals, many of whom are
also depicted in "Mr. Mabe's
Birthday Party." Evidently, Billy
Mabe was quite a successful man,
judging from his neat, well-made
house with its decorative wood-
work and from the scale of his
celebrations. By the 1960s most
of the houses in Stone Head
were gone and little was left of
the village, except the house at
the intersection where stood the
carved head from which the
hamlet derived its name.

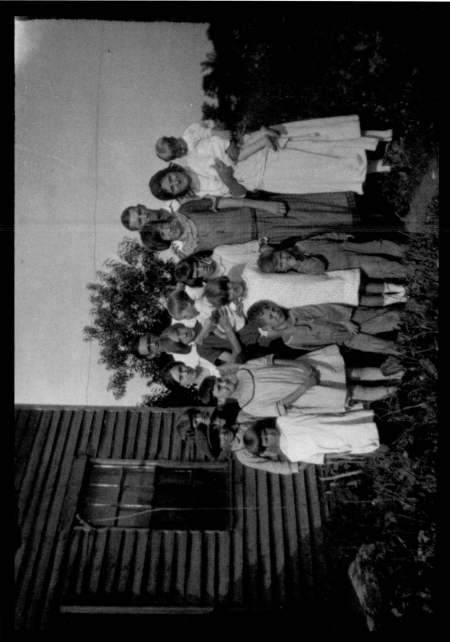

Ewers Family, 1927.

This informal gathering is made up of members of the Ewers family. The group includes a brother and two sisters of Clara Ewers Ping and their children. Irene Ping is the girl with dark hair in the center of the photograph.

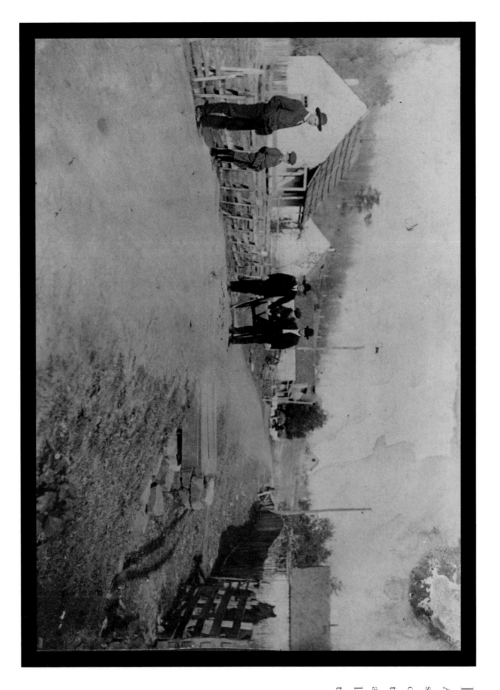

Pike's Peak in 1900.

A brief identification of this scene written on the back of the original print says "Pike's Peak, taken 1900." The photograph is a reminder to us of what hamlets looked like at the beginning of the century.

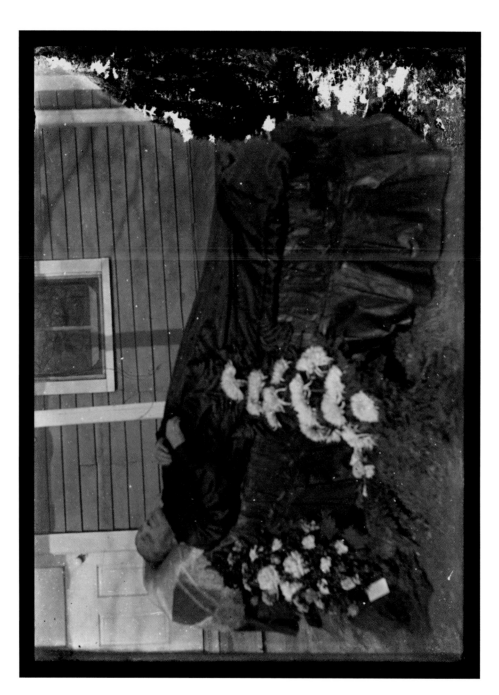

Body of Dead
Woman on a Bier.

In one of the most unforgettable images in the collection, the body of an old woman has been placed on some kind of hidden bier, lying in state on the porch of a ramshackle house. The somberness of the photograph, the simplicity of the setting, and the implications of the ritual make it a sensitive work evoking a fleeting moment in time.

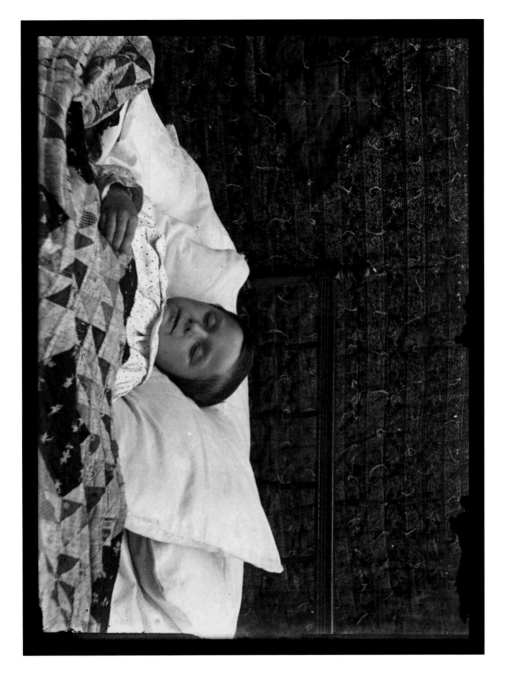

Kenneth Barker, ca. 1908.

This boy who might be sleeping is actually deceased, photographed in his bed as though death had not yet claimed him. The boy was Kenneth Barker, born in 1903. He is shown alive in the picture of the James Barker family (p. 30); Ping noted on the back of the family photograph that one of the boys was dead before he had finished printing the picture.

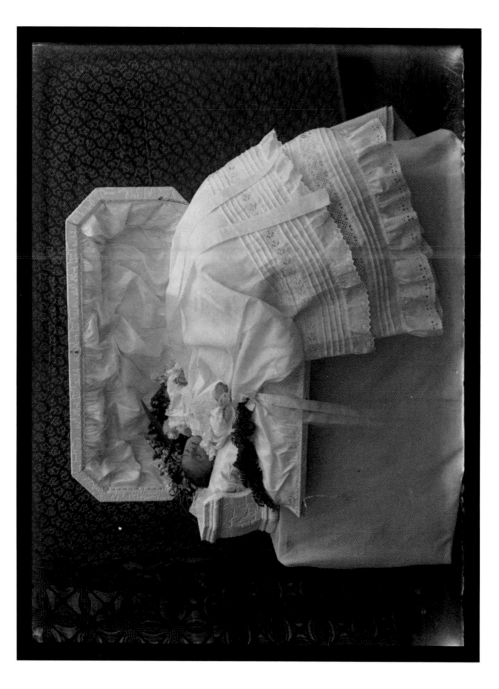

Infant in Coffin.

The lacy baptismal dress and
burial shroud of this infant is
arranged with care for what
was perhaps the child's only
photograph.

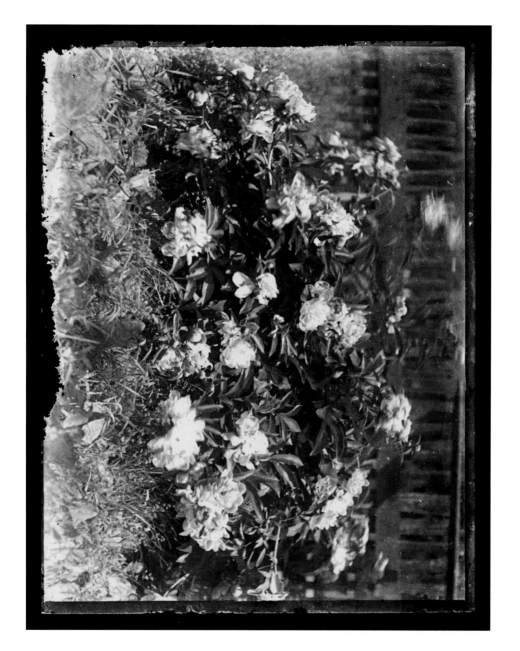

Flowers on a Grave.
These flowers appear to be
peonies, a flower commonly
found in the yards of country
houses in Indiana.

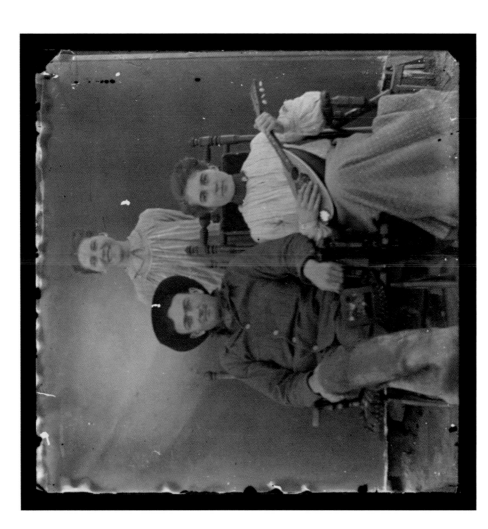

Girl Musician Seated with
Man and Standing Woman.

The subjects in this portrait
are casual looking, both in their
dress and posture. The young
woman, seated at right, is hold-
ing a mandolin and looking
straight ahead. The man, his legs
crossed and hat pushed back,
is the essence of self-assurance.

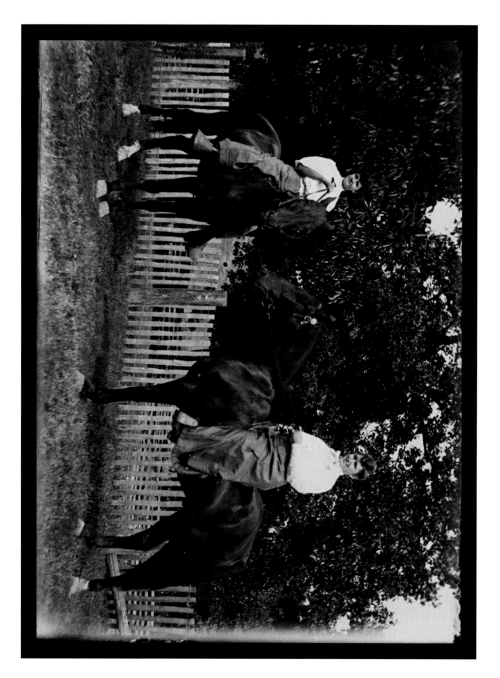

Two Women on Horseback.
In this photograph we see two
young women mounted on fine
horses, probably Morgans. The
women wear split skirts to facili-
tate riding in the saddle in the
fashion shown.

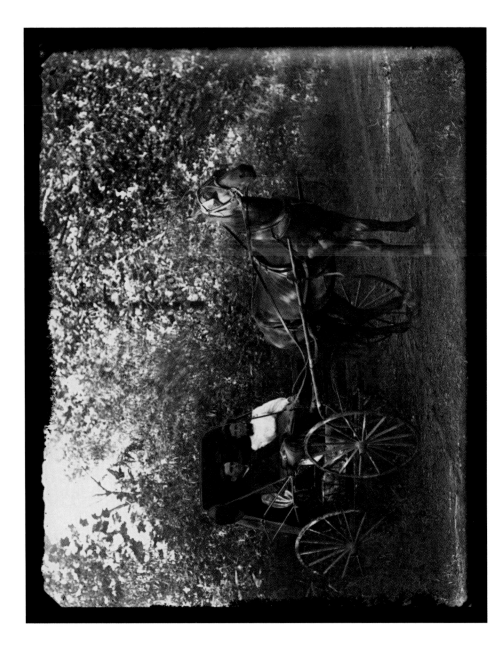

Lawrence and
Mary Stuckey.

In the late years of the nine-
teenth century and the first
decades of the twentieth the
horse-drawn buggy was a
favorite means of courtship.
Men usually kept both their
horses and buggies spotless for
such occasions. The care that
they gave to the animal, har-
ness, buggy whip, and buggy
reflected character and status.

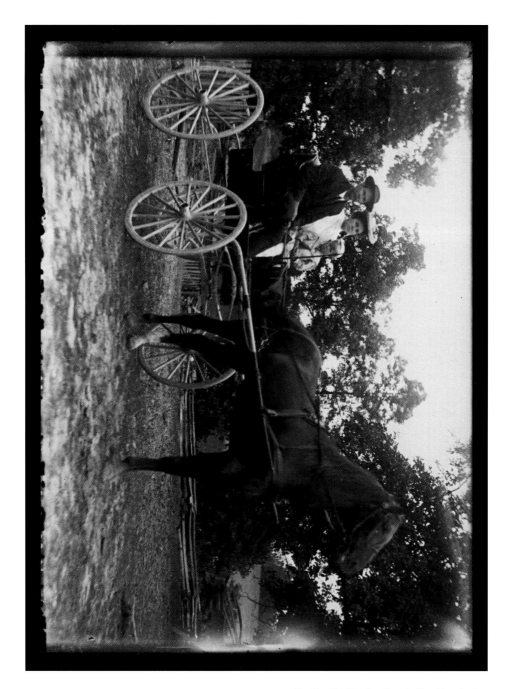

Affluent Couple.
This family group is seated in an expensive rig that is being pulled by an impressive horse. The varieties of horses seen in the Ping Collection indicate much about their owners and their lifestyles. The apparel of the family, the stylish rig, and the high quality of the animal indicate relative affluence.

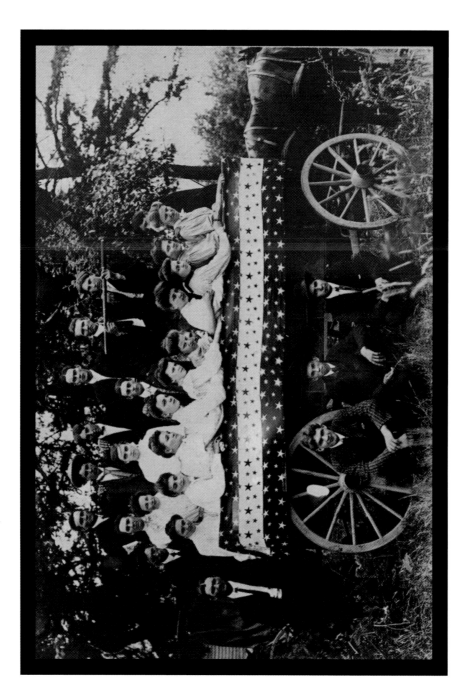

Decorated Wagon with Young People.

"Taken on Weed Patch" is written on the back of the original print. Weed Patch is the name of a Brown County hill that is skirted by Indiana 46 between Columbus and Nashville. Festive bunting is wrapped around the wagon, which is loaded with a group of young people.

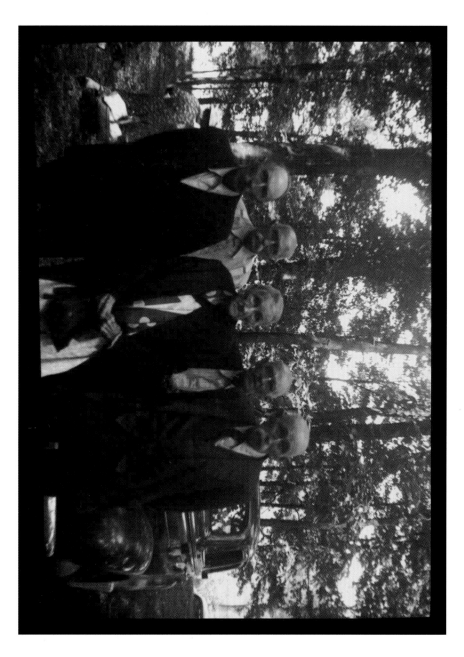

Mrs. Emaline Henderson Ping and Her Brothers.

The woman in this 1940 photograph is Otto Ping's mother, Emaline Ping, at age 89. Ping made the photograph at a family picnic that autumn. The photograph appeared in a local newspaper a week before her church, the New Bellsville Baptist Church, paid honor to her on the occasion of her having been a member of that church for 75 years. The men in the picture were four of her five living brothers: Benjamin Henderson of Columbus, 76, Jasper Henderson of near New Bellsville, 74, Freeman Henderson of Clifford, 70, and Robert Henderson of near Columbus, 78. The newspaper article reported that Mrs. Ping was "remarkably spry for a woman her age; she sews and works on her quilts without glasses, is interested in all the family activities and leads a normal life."

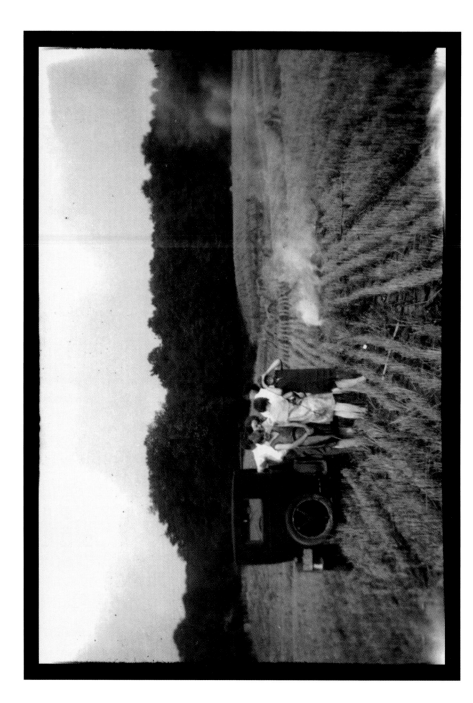

Field Destroyed by
Lightning Fire.

The photographer said that

this scene was of a field on

the Logan Ping place that had

been ravaged by a fire started

by lightning.

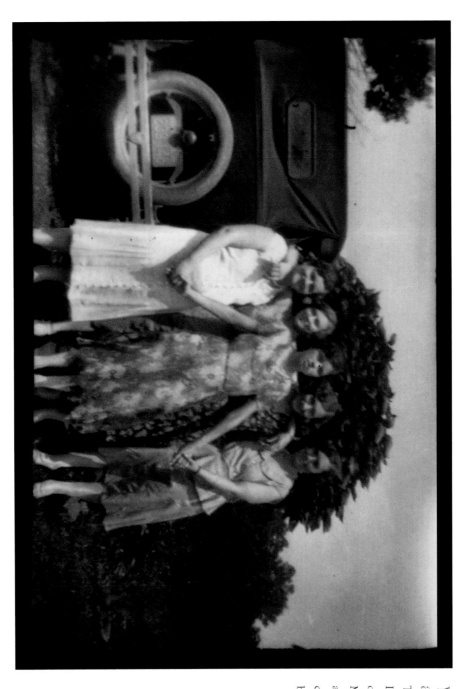

Young Women
and Touring Car.
This joyful scene shows
Irene Ping (center) with four
of her friends: Marian Richie,
Mary Bishop, Mildred Ritchie,
and Betty Polan. They were
celebrating Irene's sixteenth
birthday.

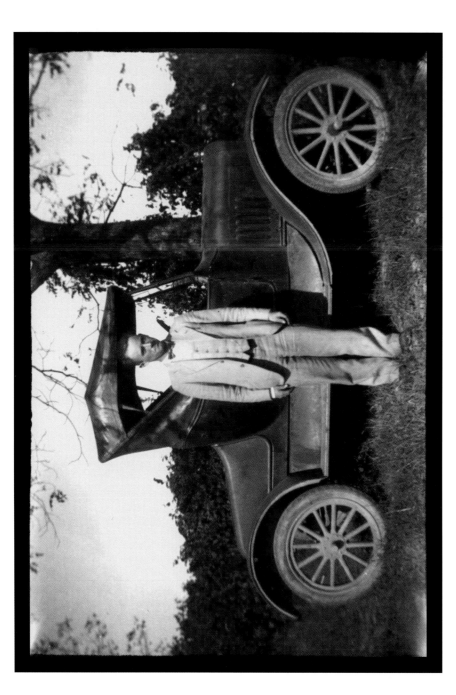

Eldon Sluss.

The young man standing beside the Ford coupe is Eldon Sluss, who later married Irene Ping. Looking closely, one can see a gold watch chain hanging across his vest in the popular style of the day.

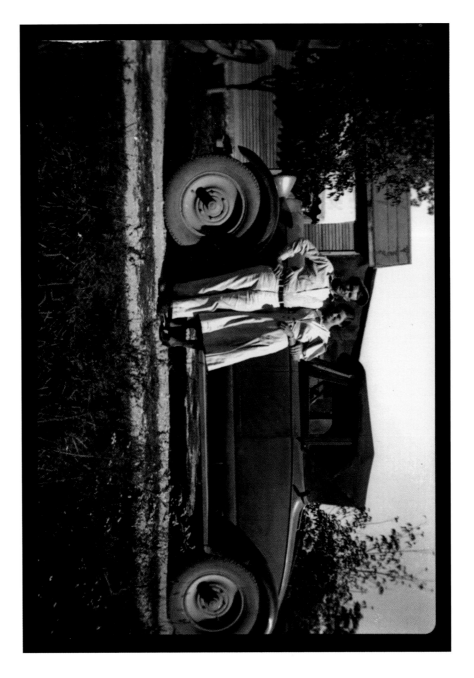

Irene Ping and Eldon Sluss.
Irene and her fiancé, Eldon
Sluss, stand proudly beside an
expensive convertible coupe.

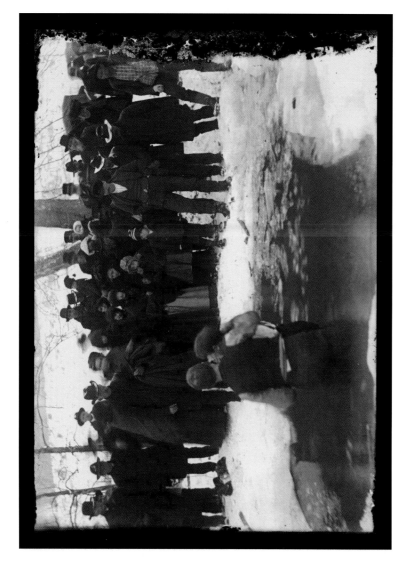

Winter Baptism.

Of all of Ping's photographs, this scene of a winter baptism in a pond is perhaps the most extraordinary. The scene is harsh and stark, with about thirty people, dressed warmly against the winter cold, huddled at the edge of the pond. This is baptism in living water, a religious ritual that was quite common in the early part of this century. A baptism in the dead of winter shows the strength of religious convictions. The harshness of life in the wilderness is reflected in most of the faces in this picture.

Band Concert, 1930s.
This scene typifies the last decade of peace between World War I and World War II. A dance band is playing on the stage of the large building in the background. The site must be a public park or a resort. One can hardly miss the large sign at the left which says "Billiards." This image, perhaps one of Otto Ping's last photographs, sums up the sense of well-being, the peace and magic of a resort, and the irresistible sounds of "In the Mood." In this photograph, we see a scene that is clearly of the twentieth century.

Otto Ping and Itinerant Photography

Anne E. Peterson

From a large family of nine brothers and sisters, at seventeen Otto Ping (1883–1975) turned to photography for supplemental income. The Pings were farmers, and money was scarce. Cameras fascinated Otto, and he recognized the need for someone to photograph in his rural Indiana community—Brown County—where few could afford photographic equipment. He bought a simple Monarch camera through the mail from Sears and Roebuck and taught himself to use it. Otto's cousin E. Grant Ping, nineteen years his elder, had been a local photographer and probably influenced him in choosing to make photographs professionally. However, by the time Otto took up camera work in 1900, Grant had moved to Mason City, Illinois, and made his livelihood as a barber. Otto Ping worked as an itinerant photographer for about forty years documenting local people, their work, and environment.

In some respects Ping differed from the usual itinerant photographer. The typical itinerant was an outsider, often traveling around to unfamiliar places searching for new photographic subjects.[1] These photographers picked up work where they could without making prior appointments. Unlike those typical cameramen, Ping was very much a part of the area in which he worked. Brown County was his birthplace and the primary location in which he lived and photographed throughout his life. While he confined his work to Brown County, Ping fits easily within the larger context of itinerant photographers, who, although little chronicled, have a long tradition that continues today. The tradition of traveling artists actually begins long before the first viable photographic process—the daguerreotype—became available in 1839. Already established were itinerant portrait artists, miniaturists, and silhouette makers, along with traveling peddlers who sold various wares. The first documented itinerant photographer was Johann Baptist Isenring, a Swiss artist who had a carriage caravan with darkroom and living quarters built in 1842, enabling him to enlarge

his work area throughout Switzerland and southern Germany.[2] By the late 1840s there were mobile daguerreotype "galleries" in America, and those early entrepreneurs were followed by photographers who used such later photographic processes as the ambrotype and tintype when they became available. In Canada and South America the first photographs were made by American and European itinerants taking advantage of a provincial market without professional studios.[3] From the beginning the itinerants charged little for their work compared with urban professionals, which in part explains their success.

Unlike Ping, for some it was the appeal of freedom from a rigid office routine and a sense of wanderlust and financial independence that drove them to choose a profession that sometimes took them from state to state in their quest for new subjects. Away for months at a time, some twentieth-century itinerants even lived and worked from their cars. Manuals were published on how to succeed with itinerant work.

Mobility is a crucial aspect of the itinerant genre. However, some so-called "itinerant" photographers worked out of large studios, traveling regionally, but always returning to their commercial base. These then would perhaps be better identified as "traveling" photographers, since while they went from place to place seeking new clientele, they were employed by professional studios. They were working on "location," as many contemporary photographers do today.

Important to the definition of the true itinerant photographer is the issue of whether or not the photographer works out of a formal studio, where subjects could come to be photographed. Such itinerants as Ping flourished in rural areas across America that could not support a commercial studio. Throughout his photographic career, at no time did Ping have or work from a professional studio. He traveled by wagon and later by truck to make his images, and he developed plates and made prints at home. Sometimes Ping may have gone out looking for subjects to photo-

graph, but since he was familiar to many of the residents of his sparsely populated native county, it is likely too that he was contacted to make such photographs as "Winter Baptism" (p. 82) and "Mr. Mabe's Birthday Party" (p. 63). In discussing the birthday party years later, Ping said, "I got my dinner. Lots of people bought pictures." While out on these assignments he would also have had the opportunity to pick up other work in the area.

It took an outgoing personality to be an itinerant photographer, and, like most, Otto Ping had an entrepreneurial bent. Income from photographic sales was always supplemental to other work. Besides farming, he raised chickens and sold eggs. He and his wife Clara canned and marketed the produce they grew. They also gave demonstrations and sold equipment for home canning. In addition, Ping sometimes made a business of trucking, and he sold Watkins home products. In spite of all his industriousness, Ping never had much of an income and certainly never saved any money.

Stylistically, itinerants fall into the category of folk artists in their uneducated, simplistic approach to their craft. As part of the folk genre, images made by itinerants are often charming in their lack of sophistication as well as moving in their directness. Like many other photographers who made rural portraiture, Ping probably did little if anything to pose his sitters or arrange groupings of people in an artistic manner. Still, some portraits are quite successful, such as "Young Woman" (p. 37). Here Ping photographed a pretty, youthful woman with one shoulder angled toward the camera and her head gracefully turned. However, many subjects stand or sit stiffly, staring directly at the camera, the images simply being a record of the clients' features. Such photographs as "Young Couple" (p. 10) have a passport-like quality. Groups often appear to have been somewhat randomly placed in front of the camera. These images remind one in a naive way of the intentional approach to portraiture of German August Sander in their unsparing documentary quality. Still other

Ping images are snapshot-like in their informality as seen in "Couple Fishing" (p. 24).

The outer edges of the quilts and cloth backdrops visible in some of the modern prints made from Ping's negatives were probably cropped from his finished prints, making them somewhat more polished than they appear without cropping. In "Young Woman with Fur" (p. 36) the subject wears her best wool coat with a fur collar and holds a muff. Probably photographed in the summertime, she is kneeling, and her bare feet are exposed at the bottom of the contemporary print. Undoubtedly some of the background fabric and her visibly bare feet would have been cropped from the photograph before adhering the image to the mount for presentation purposes.

While Ping made individual and group portraits and snapped images of people in front of their homes, in death, and at work and play, notably excluded from his body of work are wedding portraits or related group photographs. For an event as important as a wedding, people would have gone to a professional. Ping and other itinerants were more than adequate for everyday portraiture, but for such a once in a lifetime occasion as a wedding, people wanted formal, professional work, including stylized, painted backdrops, upscale furniture, and other props found in studio portraits. They wanted to be transported from the raw everyday life of Brown County to that of a more affluent dreamworld pictured in artificial backdrops.

Otto Ping certainly served his community well. His clientele was as unsophisticated as he, and they had little or nothing with which to compare his work. His clients were probably glad to have the opportunity to be photographed and were pleased with the product he provided them. People are often depicted with their most important possessions: their horse, home, or car. Their unrelenting serious facial expressions and formal clothing illustrate the importance and solemnity with which they viewed such an occasion as having their picture taken. While Ping

lacked artistic and technical training, and his images are simple in their approach, he did have an insider's perspective on the region and accessibility to his subjects. Ping's familiarity with his subjects and their way of life sometimes results in such revealing images as "Old Couple" (p. 11). Their faces are marked by years of hardship and toil. Life was tenuous for both young and old in Brown County, and Ping often worked against time to provide a family with images of the living before his efforts became memorial. Many of the portraits betray a sense of melancholy as if anticipating the need for Ping to return to make postmortem images of their dead.

Every state had itinerant photographers such as Ping. In the Midwest, at the same time Ping was working in Indiana, Hermann C. Benke and William F. C. Grams covered Wisconsin, Illinois, and Kansas. Sherwin H. Gillett had portrait studios in Wisconsin, but supplemented this work with regional photography throughout southwestern Wisconsin from 1905 to 1935. Like Gillett, William T. Roleff operated a portrait studio, but often traveled to logging camps and photographed local Minnesota scenery. A more truly itinerant photographer with stylistic and topical similarities to Ping was Ole Aarseth of Yellow Medicine County, Minnesota. During the early twentieth century Aarseth photographed in his native county, documenting people at work and making family portraits with the same straightforward approach as Ping.

In 1917 Frank M. Hohenberger set up a studio in Nashville, Indiana, the Brown County seat. He worked in the area and various locations throughout Indiana as well as in many other states, Cuba, Mexico, and Canada until his death in 1963. Hohenberger was a photojournalist, writing illustrated columns for Indianapolis newspapers on Brown County that included local news and historical and biographical sketches. In some ways Hohenberger must have presented competition for Ping, although Hohenberger's images are more stylized and show some-

thing of an outsider's perspective.

Itinerant photographers eventually came to have a mixed public image and reputation. As an insider, Ping's reputation was probably that of a photographer who was part of the community, and his clients were cordial, even inviting. This was not always the case for true "outsider" itinerants. Some were poor, looked seedy, and were known to drink heavily. Others were too high-pressure in their sales techniques. Those who photographed small children were called "kidnappers," because they claimed to take the photographs at no cost, but would return a few days later offering the images for "ransom," with the parents being easily persuaded to purchase pictures of their beloved children. "Kidnappers" was a term that came to be applied in a derogatory manner to all itinerant photographers.

As the depression era began, studio photographers came to struggle more and more to make a living, and their prejudice toward itinerants took the form of public discrediting in the press and even legal ordinances attempting to prohibit itinerants from working. In 1934, on request from studio photographers, a series of articles was published

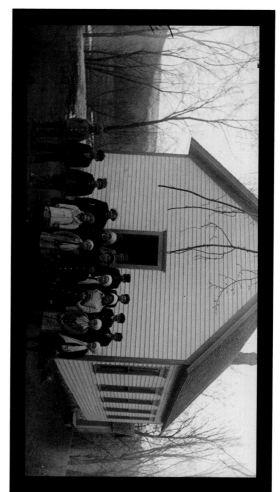

Rural Schoolhouse, near Echo (District #100, Sioux Agency Township). Ole Aarseth (Courtesy Minnesota Historical Society)

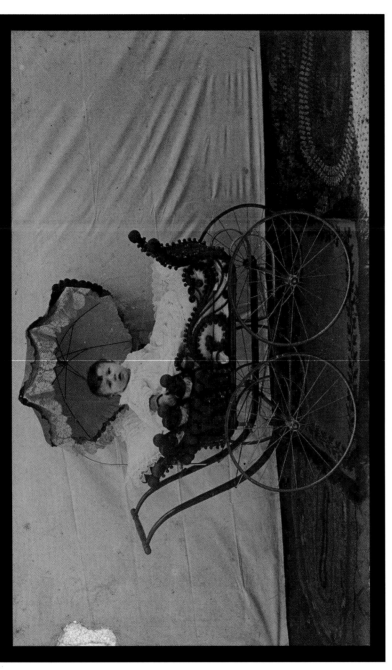

Portrait of a baby in a carriage by an anonymous itinerant photographer.

(Private Collection)

in *The Professional Photographer* on legal ordinances that could act as "effective weapons against the itinerant photographer." In February, a lengthy article came out on an ordinance passed in Fort Wayne, Indiana, which was meant to discourage itinerants. The ordinance required stiff fees of $200.00 for licenses to new photographers starting to work in the area. Already established photographers and studios in the city at the time the ordinance was passed paid only $5.00 per year for a license. In March the same journal reported that two Chicago photographers had been arrested in Fort Wayne for not having licenses and were fined $50.00 plus $55.00 in costs. The message was clearly aimed at keeping itinerants away, and ordinances were enforced.

It is unlikely that the ordinances brought an end to Ping's photographic work about 1940. Modern times encroached even on rural Brown County, Indiana. Small, portable cameras had become so inexpensive that most people could afford to have one. People could take their own snapshots of family and events of note. For special portraiture, photographic studios were now more accessible because of the automobile. Competition from formal studios, legal ordinances, the population's mobility, and inexpensive photographic equipment meant that itinerant photography was no longer practical or profitable. The itinerant legacy continued in spirit after the 1940s with photographers who worked clubs, restaurants, resorts, amusement parks, and fairs and the occasional street photo-

tographer. Today there are few street photographers except in such tourist areas as New York City's Times Square, the Alamo in San Antonio, and in Washington, D.C.

Primarily a portraitist, Otto Ping left an impressive record of his era in Brown County as well—a particular place and time. His images capture a slice of life depicting the county's individuals, families, pets, homes, and workplaces. Isolated from outside stylistic influences, Ping's work is direct and yet charming in its portrayal of his region and its populace. It was not Ping's intention to make a personal statement about the people he photographed or his surroundings. His work is important as a record of rural midwestern life and work during a forty-year period of great change in America.

Anne E. Peterson is a freelance photographic historian. She has worked as curator of photography at the Louisiana State Museum and as a contract archivist at the Archives Center of the National Museum of American History, Smithsonian Institution. Her publications include "Louisiana Photography: An Historical Overview" in Century of Vision: Louisiana Photography, 1884–1984 (1986) and "Pops Whitesell: A Hoosier in the Vieux Carré" in the spring 1991 issue of Traces of Indiana and Midwestern History.

Notes

1. Sybil Miller, *Itinerant Photographer: Corpus Christi, 1934* (Albuquerque: University of New Mexico Press, 1987). Much background information regarding itinerant photographers can be found in this book. I also spoke to Miller about itinerants and wish to thank her and the following for sharing their thought with me: Roy Flukinger, Curator, Photography and Film, Harry Ransom Humanities Research Center, University of Texas; David Haberstich, Head, Photographic Collections, Archives Center, National Museum of American History; John Lawrence, Director of Museum Programs, The Historic New Orleans Collection; Carolyn Long, Department of Conservation, National Museum of American History; Christine Schelshorn, Archivist, State Historical Society of Wisconsin; and Bonnie Wilson, Curator of Photography, Minnesota Historical Society. Special thanks go to editor J. Kent Calder, Indiana Historical Society, and to my family for their encouragement and support throughout the project.

2. Helmut Gernsheim, *The Origins of Photography* (New York: Thames and Hudson Inc., 1982), 164.

3. Naomi Rosenblum, *A World History of Photography* (New York: Abbeville Press, 1989), 52.

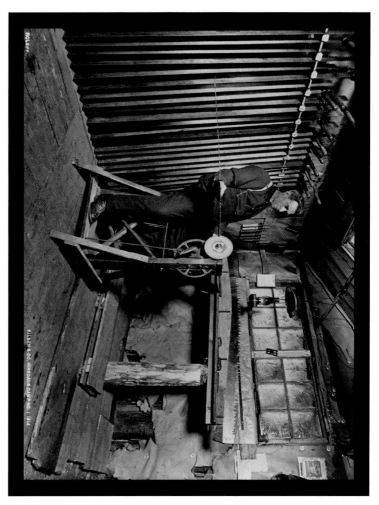

Sharpening Saws, Kileen and Co., Hinsdale Camp #1, Minnesota 1914.
William Roleff (Courtesy Minnesota Historical Society)

Significant beyond Intent
Stephen J. Fletcher

The process by which the Otto Ping Collection has been reunited at the Indiana Historical Society began casually. One morning in early 1989 coworker Susan Sutton informed me of a conversation she had had the previous Saturday while on duty at the Indiana Historical Society Library reference desk. A woman had told Sutton that her father-in-law had been a photographer in Brown County in the early 1900s and that the family still had many of his glass-plate negatives. She also mentioned that many of the negatives had flaking or damaged emulsions, and she wanted to know the best way to preserve them. Sutton conveyed information about the need for archival envelopes, cool temperatures, and low, nonfluctuating humidity levels. She told me that, as she gave the woman this information, she sensed an interest in possibly donating the collection to the Society.

The woman's name was Wilma Ping, and her story sounded familiar. I searched and found a letter she had written to the Society in late 1988 with the same questions. I set aside both Sutton's telephone message and Ping's letter, intending to investigate the matter, but did not respond immediately.

In February J. Kent Calder, editor of the Society's illustrated history magazine *Traces of Indiana and Midwestern History*, asked me to read a manuscript submitted for possible publication. The article, written by W. Douglas Hartley, unveiled the story of a man named Otto Ping whom Hartley had met while researching Henry Cross, a Brown County stone carver. (The Indiana Historical Society published Hartley's book on Cross in 1966.) While talking one day with Ping about Cross, Ping confided to Hartley that he had been a photographer in Brown County and still had his negatives in the attic. Ping loaned Hartley several of his negatives and photographs in 1974, and Hartley still had them in his possession and used them as the basis for the submitted manuscript.

The casual beginning now seemed like a harmonic con-

vergence. I soon contacted Wilma Ping and arranged to visit her and her husband Bryce at their home in Tampico, Indiana. Just before entering the village, I sat in my car at the side of the road and reread Professor Hartley's manuscript. I studied the photocopied images and felt my hopes rising that I would soon be examining the original negatives from which they had been printed, and better still, additional negatives and photographs. During my visit, Bryce and Wilma told me stories about Otto and the Ping family. They showed me a pocket notebook listing clients and told me about two pocket-size diaries that Otto kept in 1908 and 1909 in which he occasionally mentioned making photographs. I looked at a couple hundred glass negatives and photographs and realized that, while most of the negatives were not stunning, they had a revealing quality. The poor condition of several negatives precluded a detailed examination. The afternoon at the Pings was enjoyable and informative, and I left with a small jar of homemade jelly and grand thoughts of reuniting Otto Ping's work at the Indiana Historical Society.

Bryce Ping and Irene Sluss, Otto Ping's son and daughter, eventually agreed to donate all of Otto Ping's remaining negatives in their possession to the Indiana Historical Society. They also gave the negatives and photographs on loan to Hartley, an account book, the two daybooks, and several canning labels used by Otto Ping in his Home Products Association operation. The collection includes nearly 300 glass and film negatives, and 32 vintage photographs. The glass negatives vary in size from 2" x 2" to 8" x 10", with 5" x 7" being the predominant format. Ping's daybooks contain brief, prosaic entries that always include a description of the weather.

As Anne E. Peterson's essay attests, Otto Ping was not unique in the photographic world; he was singular to turn-of-the-century Brown County, however, and that is why his photographs are important. In 1900 census takers for Brown County counted only one photographer—James

Whitaker in Nashville. If Whitaker had his own portrait studio, it would probably have been much like those of his counterparts in the nearby cities of Bloomington and Columbus. The population in Nashville in 1900 numbered only 391, so Whitaker's clientele would probably have come from citizens visiting the county seat. If this was his plan, it likely proved to be unwise. By 1910 Whitaker, still residing in Nashville, was a stonecutter in a marble shop,[1] and the only photographer counted by census takers that year was Vanamburgh B. Frost, a fifty-four-year-old traveling photographer native to Ohio. In 1920, with the population of Nashville dwindled to 308 (a drop of more than 20 percent in twenty years), Frank Hohenberger was the county's only recorded photographer.[2]

Though Ping apparently had no studio of his own, he may have utilized someone else's. A document recently discovered in a notebook that remains in the Ping family lists Otto Ping's clients and their addresses; the date, quantity, and amount of orders; where he delivered orders; and the charge and amount paid by clients. The form records orders placed during an eleven-day period from 16 to 26 August 1905 and includes fifty-four orders, forty-eight of which are dated 22 August. Ping delivered most of his orders, but he wrote "get at gallery" for delivery information for eight of the patrons. This notation more than likely represented a gallery where Ping had the photographs made.

The list shows that Ping offered card photographs up to 11" x 14", and one client even ordered "Buttons." Most of the surviving vintage Ping photographs from this period are made on "printing out" papers, whereby the photographer placed the negative directly in contact with the photographic paper. He placed this sandwich into a contact printing frame, which he then exposed to sunlight until properly exposed. The photographer finished the process by washing the properly exposed photograph in water. In order to provide his patrons with 11" x 14" photographs,

Ping would have needed an 11" x 14" camera, which seems unlikely, or taken his negatives to another photographer who could make enlargements. Moreover, the largest negatives in the collection are 8" x 10", but only three are extant, two of which are of the same event—a portrait of a large group that the Ping family identified as Grandpa Ping's birthday party in 1906.[3]

There are no other documents that state or imply that Ping operated a studio or gallery, or that he had the ability to make enlargements or photo buttons for his patrons. In his daybook for 22 January 1908 Ping wrote, "Went to Columbus and had a few plates developed and a few prints finished." In early April before his departing Brown County to sell medicines, he noted printing pictures at home on his birthday, 3 April, and a week later, "finishing pictures" at home. On his return on 10 May he stopped in Columbus but did not mention his activities other than that he stayed with his Uncle Freeman overnight. On 12 May, after traveling in central Indiana for nearly a month, Ping wrote, "Delivered some frame [sic] & an enlarged picture at Beck's one to Thompson and one frame to Orval Barker & two B. Z." This sketchy information suggests that Ping both printed his own negatives and had work done for him in Columbus; it is important to note, however, that the record of orders and the daybook entries reflect activities that were three years apart.

There are some tantalizing entries in the daybooks that provide only glimpses of Ping's photographic activities. He began 1908 in a partnership in a store at South Bethany with Laurence E. Stuckey, his sister Mary's husband, whom she married in 1906. In mid-March and again in early April Ping went to Indianapolis and contracted to work for the J. R. Wasson Company, a manufacturing "chemists" firm.[4] On 7 April Ping "sold my camera and outfit to Chas. & Dole[?] for $15.00[?]." On 14 April he left Indianapolis with a load of medicines and headed for Frankfort. With his horse sick in a livery stable, he returned to Indianapolis on 10 May and had dinner with

"J. R.'s father in law," then continued on to Brown County. A week later he returned to Frankfort to find his horse worse than when he left. Ping went back to Indianapolis, and then home to prepare the truck patch for planting.

On 14 May Ping "Went to Burg at night to meeting and got H. C.'s camera and returned]." Two days later, he "delivered some enlarged picture [sic] West of Gnawbone." There are no other entries for the entire year regarding the making of photographs for sale. He mentions personal photographs in late May. Ping's first mention of Clara Ewers notes that he and she had their picture taken at an artesian well on 24 May and on the following day he jotted down, "I had a kodack and took some picture." His final note on photographs for the remainder of the year was on 14 June: "Went to the oil well at Shadows picture took."

Ping bought a horse two days later and returned to the Frankfort area, peddling medicines until late July. In mid-August he went again for another month's stint, after which he returned home and helped with the harvest. In late November Ping set out for Frankfort once more, working his way east to Summitville, where he picked up Clara Ewers. The couple spent the remainder of the year together, including a trip to Gas City.

Ping did not write an entry into his 1909 daybook until late February, and there is no mention of photography until 26 May, when Ping "went down below Christiansburg to get a picture for enlargement." Two months later he "went to Pete Stidham and got box picture frames and an enlarged picture of Ella Carmichael," and a few days later, "delivered an enlarged picture to Philip Carmichael." He made a photograph of a Sunday school group and a baby in early August. In early September Ping photographed a dinner; in midmonth he noted, "had my pictures taken in a group by the bridge" at Wolf Creek and that he had photographed a group. On 26 September Ping photographed a group for a friend, and

"some scenery of Pikes Peak, Stone head, Mt. Zion . . . and Wolf Creek." He noted taking a picture of Mrs. Collyer's house in mid-October. On Sunday 31 October Ping "Went over to Shaffers and got camera and took dinner with them went down on Wolf Creek to see Lulu Richey." A few days later, he "went to Shaffers took camera home (took no pictures)." By week's end, Ping "finished a few pictures taken on Wolf Creek."

These tidbits for 1909 are gleaned from entries devoted largely to farming activities. Ping reported himself as a farmer to census takers in 1910 and 1920, noting in the latter year that he was a truck farmer.[5] It is evident that he never saw himself principally as a photographer. After examining all of his negatives, it is clear that he was not technically proficient with the craft of making photographs. The consistency of his negatives varies greatly in exposure and are often out of focus. He did, however, know the limits of his equipment: large groups such as Mr. Mabe's birthday party, for example, are strung across the scene because of his camera's limited depth of field.

Despite these shortcomings, Ping's photographs project an aura of authenticity. A journeyman with a camera, Ping photographed exactly what was before him. His subjects are not posed to look quaint or folksy. Their faces are not retouched; they are captured on glass just as Ping and others saw them every day. His views are not original, but neither are they pedestrian. A child's gesture, an elder's stare, a shoe—each reveals details about the people and their objects in their own place and time. Without Ping's photographs we would not have such an honest representation of their lives.

John Szarkowski, in the introduction to The Photographer's Eye, speaks to the photographs made by Ping and others like him during the late nineteenth and early twentieth centuries. With the advent of the dry plate negative, thousands of people took to photography and, without any artistic training, "made pictures that were unlike any before them. . . . Most of the deluge of

pictures seemed formless and accidental, but some achieved coherence, even in their strangeness. Some of the new images were memorable, and seemed significant beyond their limited intention."[6] Otto Ping's photographs fall into each of these categories. Spend time with the photographs represented here. Retrace the steps of Otto Ping and discover the significance that lies beyond the intent of these genuine, regardful, and considered images.

*Stephen J. Fletcher is the Indiana Historical Society's curator of visual collections. His articles on photography include "The Business of Exposure: Lewis Hine and Child Labor Reform" (*Traces of Indiana and Midwestern History, *spring 1992) and "A Longer View: Crikut Photography in Indiana since 1906" (*Traces of Indiana and Midwestern History, *winter 1991).*

Notes

1. In 1920 Whitaker listed himself as a sculptor.
2. Hohenberger opened his studio in Nashville in 1917. The 1920 census also lists James M. Lormore, from Hamblen Township, as a photographer, but he was eighteen years old and working for wages. As such, he was probably working for another photographer in the vicinity, rather than operating his own studio.
3. Job Ping, Otto's grandfather, was born 25 August 1800 and died in 1883. If the family celebrated a reunion on the anniversary of Job's birth, that date fell on a Saturday in 1905 and on a Sunday in 1906.
4. In the 1909 Indianapolis city directory, J. R. Wasson, president of the company, resided in Tucumcari, New Mexico; C. S. Merrick was secretary and treasurer for the firm with its facilities at 1737 English Avenue.
5. In 1900 Otto Ping was seventeen years old, and the census indicates he spent at least six months in school during the preceding year.
6. John Szarkowski, *The Photographer's Eye* (New York: The Museum of Modern Art, 1966), 7.

Bibliography

Alley, Hartley, and Jean Alley. *Southern Indiana*. Bloomington: Indiana University Press, 1965.

Bastin, Dillon. *If You Don't Outdie Me: The Legacy of Brown County*. Bloomington: Indiana University Press, 1982.

Byrd, Cecil K., ed. *Frank M. Hohenberger's Indiana Photographs*. Bloomington: Indiana University Press, 1993.

Carter, John. *Solomon D. Butcher: Photographing the American Dream*. Lincoln: University of Nebraska Press, 1985.

Chapell, George. *The Itinerant Photographer*. New York: Schoenig and Company, 1936.

Coke, Van Deren. *One Hundred Years of Photographic History*. Albuquerque: University of New Mexico Press, 1975.

Forsee, Aylesa. *Famous Photographers*. Philadelphia: Macrae Smith Co., 1968.

Gernsheim, Helmut, and Alison Gernsheim. *The History of Photography*. New York: McGraw–Hill, 1969.

Hartley, W. Douglas. "Shadows of the Past: The Photographs of Otto Ping." *Traces of Indiana and Midwestern History* 2 (winter 1990): 39–47.

Hawthorne, Ann, ed. *The Picture Man: Photographs by Paul Buchanan*. Chapel Hill: University of North Carolina Press, 1993.

Junge, Mark. *J. E. Stimson: Photographer of the West*. Lincoln: University of Nebraska Press, 1985.

MacCandless, Barbara. *Equal before the Lens*. College Station: Texas A & M University Press, 1992.

Miller, Sybil. *Itinerant Photographer: Corpus Christi, 1934*. Albuquerque: University of New Mexico Press, 1987.

Newhall, Beaumont. *The History of Photography: From 1839 to the Present Day*. New York: Museum of Modern Art Press, 1982.

Penn, Irving. *Worlds in a Small Room*. New York: Grossman, 1974.

Rosenblum, Naomi. *A World History of Photography*. New York: Abbeville Press, 1989.

Scully, Julia. *Disfarmer: The Heber Springs Portraits, 1939–1946*. Danbury, N.H.: Addison House, 1976.

DATE DUE